ROYAL WESTMINSTER & ST JAMES'S

THROUGH TIME

Brian Girling

AMBERLEY PUBLISHING

Acknowledgements

Grateful thanks are offered to Judge's Postcards Ltd (Hastings) and Maurice Friedman, who have kindly permitted the inclusion of their images in this book. Additional research by Ian Vanlint is also gratefully acknowledged.

Books consulted include: *The Buildings of England: London, Vol. 6* by Simon Bradley and Nikolaus Pevsner; *The London Encyclopaedia* by Ben Weinreb and Christopher Hibbert; *The Westminster and Pimlico Book* by Richard Tames.

First published 2013

Amberley Publishing
The Hill, Stroud
Gloucestershire, GL5 4EP

www.amberley-books.com

Copyright © Brian Girling, 2013

The right of Brian Girling to be identified as the Author of this work has been asserted in accordance with the Copyrights, Designs and Patents Act 1988.

ISBN 978 1 4456 1072 6

British Library Cataloguing in Publication Data.
A catalogue record for this book is available from the British Library.

Typeset in 9.5pt on 12pt Celeste.
Typesetting by Amberley Publishing.
Printed in the UK.

Introduction

The City of Westminster has been at the heart of English history for over 1,000 years, with its royal palaces and its mighty abbey where English monarchs have been crowned since the reigns of Harold II and William I (William the Conqueror) in 1066. It is also the seat of government, and the beautiful Palace of Westminster (The Houses of Parliament) form a grand riverside skyline known worldwide.

Westminster's story began with the Thames, as did Roman London's – Londinium was founded a mile downstream around AD 43. This evolved into the financial powerhouse of the City of London, while Westminster became the chosen abode of royalty, the aristocracy and government.

We are all familiar with the soaring Gothic splendours of Westminster Abbey, but this great church began modestly enough around the seventh century, when a monastery was set up on Thorney Island, a scrubby eminence in the riverside marshes.

Successively built and rebuilt through the centuries, the abbey's magnificence grew, witnessing coronations, royal jubilees, weddings and funerals, often amid scenes of opulence and pageantry.

The Palace of Westminster traces its origins back to the eleventh century, its present appearance the result of rebuilding following a fire in 1834 and its iconic clock tower 'Big Ben' a symbol of London known everywhere. Royal palaces abound, including fragments of Whitehall Palace, once the principal London residence of the monarch, Henry VIII's St James's Palace and Buckingham Palace, the sovereign's home since the reign of Queen Victoria. Government departments and ministries settled around Whitehall, their grand Victorian buildings replacing old residential neighbourhoods bordering Parliament Square.

Southern Westminster is, however, much more than a location for its great heritage sites. It has always been a living, working city, once filled with crowded streets and populous neighbourhoods. Now there are new hotels catering for the increasing number of visitors, as well as mansion flats for the new generation of city dwellers.

Scenes of royal and military magnificence are commonplace in Westminster, but it is the purpose of this book to show something of the great stage upon which they are set, with modern photographs depicting how they have changed over the past decades.

We may therefore take a look at the industrialised mini-dockland, which existed in the shadow of Parliament's mighty towers and grandiose Parliament Square when still bordered by modest domestic buildings.

The beauties of Westminster have attracted the photographer since street photography was pioneered around 1839. The images in this book date back to the late 1850s, through to Edwardian times and beyond, and come in a number of forms, including stereoscopic pairs, *cartes-de-visite*, Victorian lantern slides (often hand-tinted in the days before colour photography) and an assortment of works by a legion of often anonymous photographers. We have also utilised those peerless purveyors of Edwardian photo-reportage – picture postcards – which were highly popular in days when photographs in newspapers were rare.

The concluding pages of this book take a look at the wider area of St James's, with its grand hotels, aristocratic gentlemen's clubs, and fragrant emporia devoted to gentlemen's grooming and tailoring. Royal residences and the presence of fine art galleries and auction houses also give this quarter its own distinct ambience.

Royal Westminster & St James's Through Time is a book of comparisons, enabling us not only to see the transitions which have taken place in the city, but also those areas that remain the same, as with pomp and pageantry Westminster continues to celebrate its royal heritage with undiminished fervour.

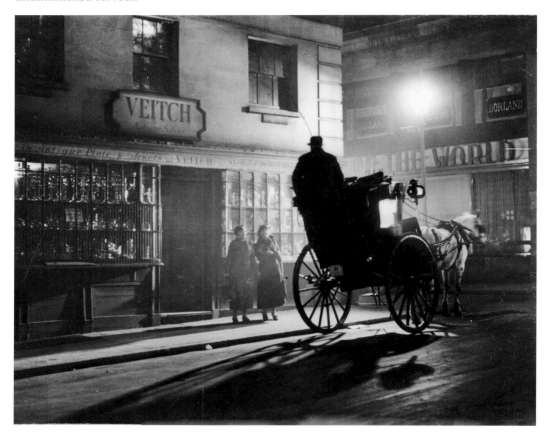

In Carlton Street, Regent Street, *c.* 1932
The aristocratic atmosphere of London's old West End has been caught in this study, but the photograph is of a later date than it appears – the already redundant hansom cab has been brought in to enhance the period feel.

The shop belonged to silversmith Henry Newton Veitch, and with its original multi-paned windows it was a rare Regency survival from the days when John Nash's great Regent Street project introduced its fashionable shops and classical stuccoed terraces to the West End. The rise of plate glass windows had, for the most part, banished this early style and the days of this example were numbered. The modern scene shows the uninspiring back of Rex House (1937–39), Regent Street, while Veitch's business moved to Jermyn Street, St James's.

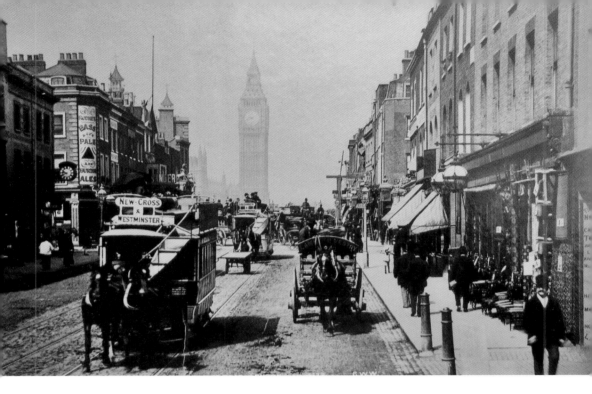

Westminster Bridge Road, *c.* 1906

Westminster Bridge first linked the Surrey and Middlesex shores of the Thames from 1750; the rebuilt bridge we know today opened in 1862. Here was the grandest approach to Westminster, the broiling streets of Lambeth dramatically giving way to a glorious panorama of Pugin and Barry's Palace of Westminster, the Houses of Parliament, and the mighty clock tower, popularly named 'Big Ben' after the great bell that chimes the hour. Westminster Bridge Road typified Victorian South London, with its horse trams, raucous pubs and lively street life, but the building of County Hall, the home of London government from 1922 to 1986, brought a sober new look. (*Photograph by George Washington Wilson*)

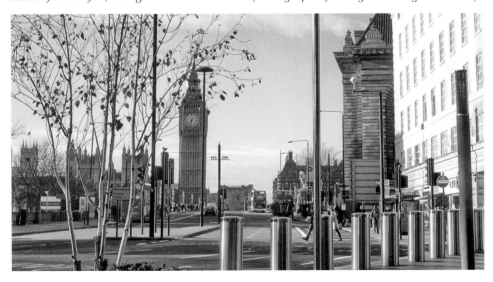

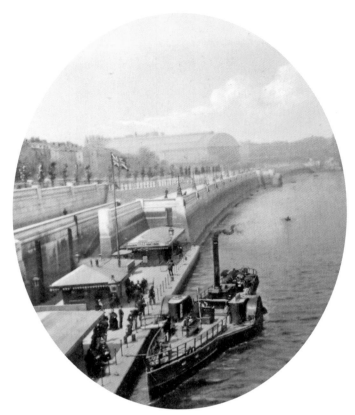

Victoria Embankment and Westminster Pier from Westminster Bridge, *c.* 1880
The impressive sweep of the Thames is common to both views but the earlier one is lacking the familiar landmarks of the present day, including the former New Scotland Yard (by Norman Shaw from 1888) and Whitehall Court (1887). Private houses and gardens still bordered the new highway, which opened to pedestrians in 1868 and to road traffic in 1870. Victoria Embankment was designed by the Metropolitan Board of Works chief engineer Sir Joseph Bazalgette and included a revolutionary new sewerage system. River trips from Westminster Pier were as popular in Victorian times as they are today. (*Unnamed lantern slide*)

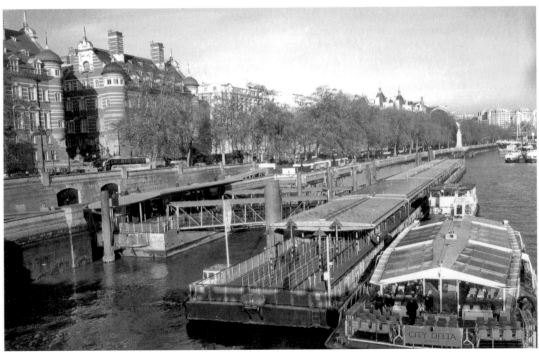

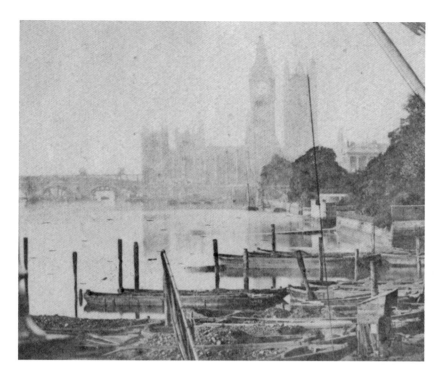

The Thames Foreshore Before the Building of Victoria Embankment, 1858
The Victoria Embankment's vast building works reclaimed over 30 acres of land from the river between Blackfriars and Westminster. This image, from a rare stereoscopic pair, and its modern counterpart gives an indication of the scale of the reclamation. The modern image shows part of the excavations from 1938–39 (on the right), which revealed a flight of steps and an early river wall. These are Queen Mary's Steps; everything to the left of them was once part of the river and foreshore. (*French tissue stereo card, 1858*)

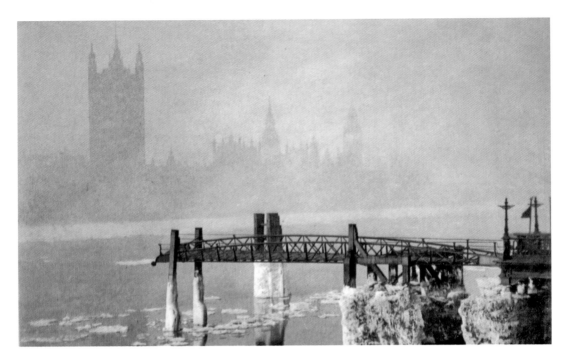

The Palace of Westminster (Houses of Parliament) from Lambeth, 1893
The Tudor Perpendicular architecture of the Palace of Westminster was the work of Charles Barry and A. W. N. Pugin. It was built from 1840 to replace the medieval palace, which was mostly burnt down in 1834. This remarkable visual spectacle has long been an inspiration for artists and photographers striving to capture the changing effects of the river light. The palace when seen on a foggy day has a romantic appeal, as captured here by an amateur Victorian photographer during the frigid winter of 1893 when ice coated the staging on the Lambeth bank. (*Unnamed photographer*)

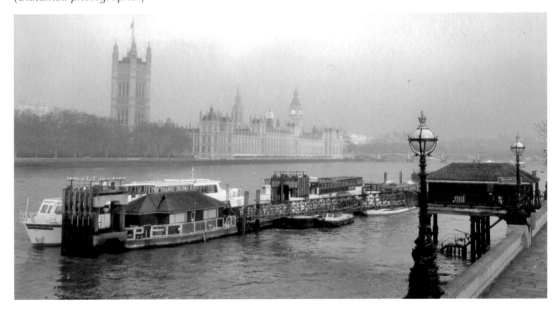

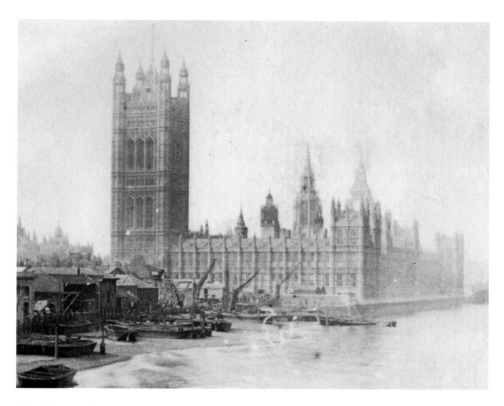

The Palace of Westminster, *c.* 1865
The grand spectacle of the palace's Victoria Tower rising high above a jumble of wharves and jetties enhanced the dramatic impact of the former until the embankment wall was extended and new gardens laid out over the old industrial sites. (*Unnamed photographer*)

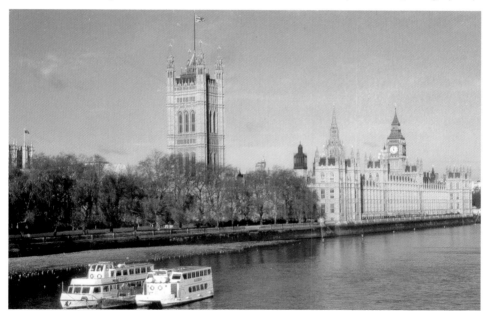

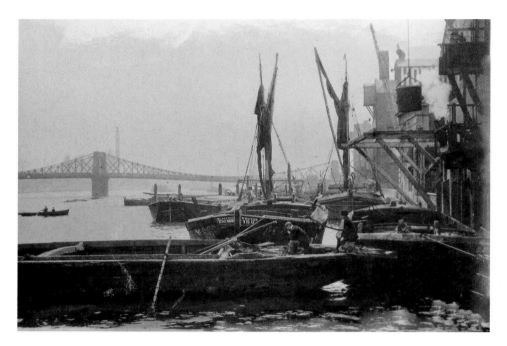

Westminster's Industrial Riverside and Old Lambeth Bridge, *c.* 1895
Sail barges and lighters moored off a ragged assembly of jetties and wharves, which accommodated stone, timber and coal merchants, pumping stations, and a pair of pubs on the landward (Millbank) side. The early twentieth century saw the demise of this ancient quarter as the leafy Victoria Tower Gardens were laid out in several stages. Old Lambeth Bridge opened in 1862 to replace an old ferry but it was frequently derided as being weak and ugly. King George V opened its handsome replacement in July 1932. (*From a Victorian photograph album*)

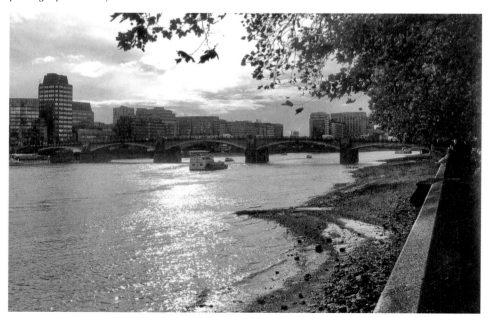

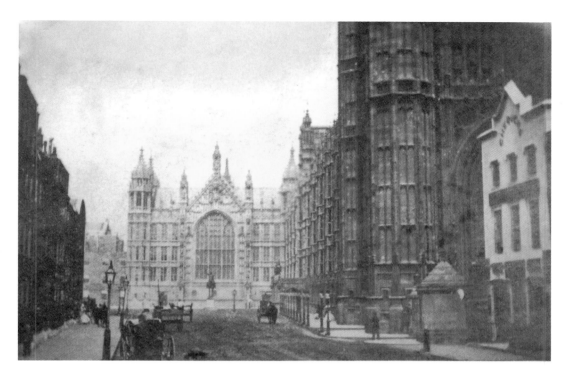

Old Palace Yard and Abingdon Street, from Millbank Street (Millbank), *c.* 1862
Old Palace Yard is overlooked by the great window of Westminster Hall, which was built from 1097 and is Britain's largest Norman hall. The hall survived the fire of 1834, which destroyed much of the old palace. Old Palace Yard takes its name from the palace founded by Edward the Confessor (1042–66) and contains an equestrian statue of Richard I (1189–99) put up in 1860. The Chequers pub on the right shows how buildings once ran right up to the palace's Victoria Tower. (*Unnamed carte-de-visite*)

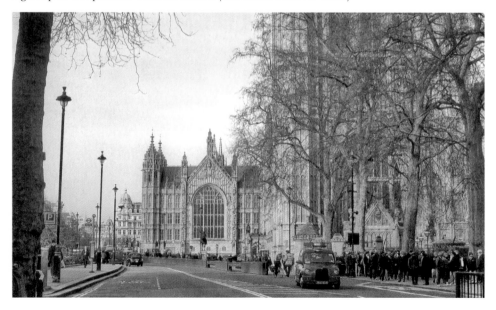

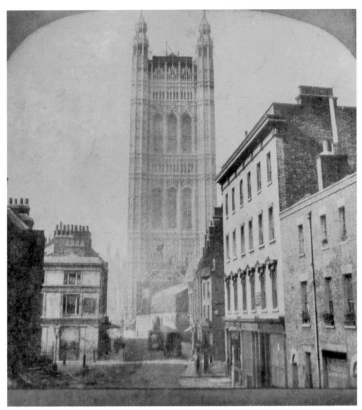

The Victoria Tower, Palace of Westminster, from Millbank Street (Millbank), *c.* **1867**
The sight of the 323-foot Victoria Tower, rising high above its old neighbourhood gave Victorian London one of its most dramatic streetscapes. This effect has since been lost, however, as mature trees partly screen the old vista. The neighbourhood of the 1860s was one of riverside wharves and workshops but there were also Georgian houses and shops before the street was widened in the later Victorian era. The Portman Arms pub on the old building line is seen on the corner of Wood Street (Great Peter Street). (*Stereoscopic photograph*)

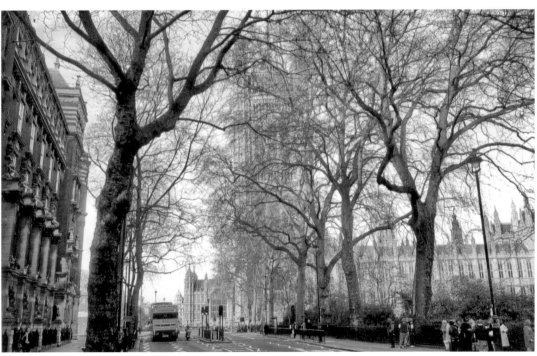

Abingdon Street by Great College Street, c. 1906
This eighteenth-century terrace facing the Palace of Westminster was a remnant of the old mixed neighbourhood close to Westminster Abbey, but war damage hastened its demise, clearing the way for College Green which sits above a subterranean car park (1963–66). These works opened out a fine panorama of Westminster Abbey and revealed the previously obscured Jewel Tower, which was built in 1366 as part of the Palace of Westminster. It was built by Edward III and securely housed the King's personal treasure. (*Postcard by unnamed photographer*)

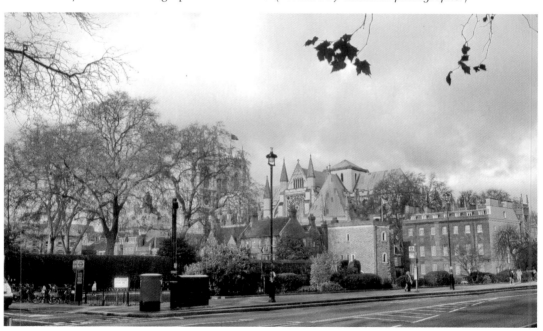

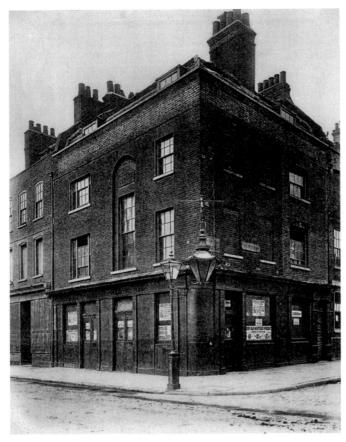

The Jolly Miller, Millbank Street (Millbank) by Church Street (Dean Stanley Street) Westminster's industrialised riverside neighbourhood closely resembled London's traditional docklands with raucous pubs and housing conditions which were, in part, as poor as any to be found in the city. All of this was in contrast to the handsome quarter which arose following early twentieth-century clearances. This corner typified the transformation – the old pub is seen in its final days, the name a possible reference to flour mills close by. (*Unnamed photographer, courtesy Maurice Friedman*)

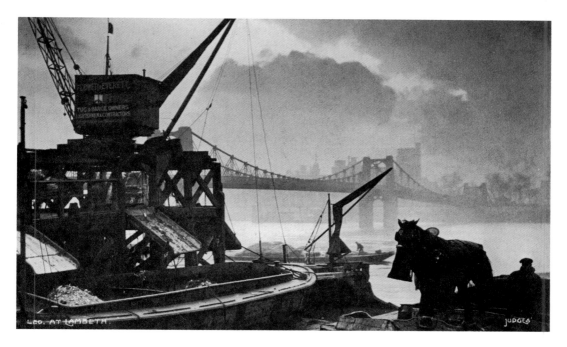

Old Lambeth Bridge, Millbank, c. 1906
An atmospheric study of the busy Westminster foreshore, which was accessed via a slipway beside old Lambeth Bridge before the river was embanked and gardens were created early in the 1900s. The old bridge replaced the former ferry crossing in 1862, but it was an inferior effort and its fine new replacement opened in 1932. This was designed by London County Council's engineer, Sir George Humphreys, and architects Sir Reginald Blomfield and G. Topham. (*Courtesy Judge's Postcards, Hastings*)

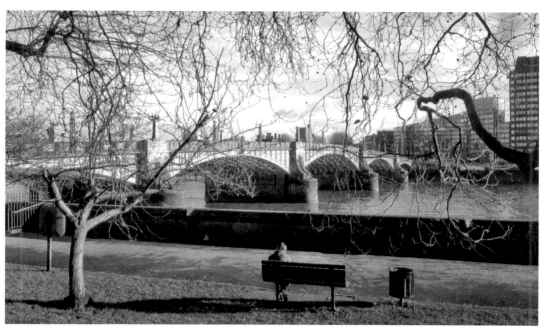

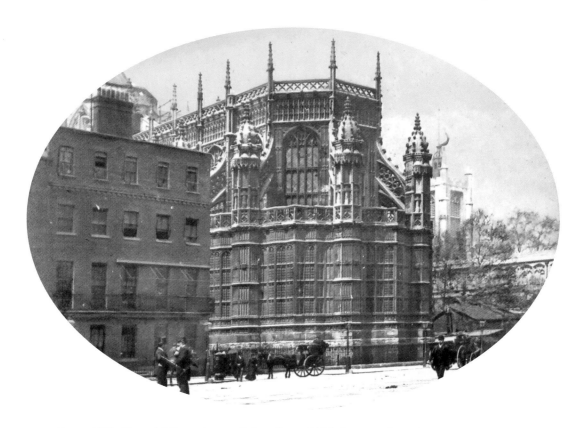

Henry VII's Chapel, Westminster Abbey from Old Palace Yard, *c.* 1895
One of Westminster Abbey's countless glories, this spectacular example of the Perpendicular Gothic style was built from 1503 to 1510 as a Lady chapel at the behest of Henry VII. The intricate exterior was formerly partly obscured by the Georgian houses in Old Palace Yard – their removal opened up a fine view. King George VI unveiled the statue of his father George V in 1947. (*Unnamed photographer*)

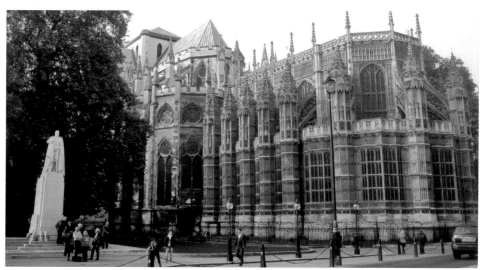

The West Front, Westminster Abbey, with the Coronation Annexe, June 1902
The coronation of King Edward VII had been planned for June 1902, but due to the King's illness the ceremony did not take place until 9 August of that year. The preparations for the June date were well under way when this photograph caught the final stages in the building of the Coronation Annexe. Most coronations at the abbey feature these elaborate temporary structures; they provide space for those taking part in the coronation procession to assemble while awaiting the arrival of the monarch. The annexe erected for the coronation of George VI in 1937 was in the Art Deco style of that decade. (*Amateur photographer's postcard*)

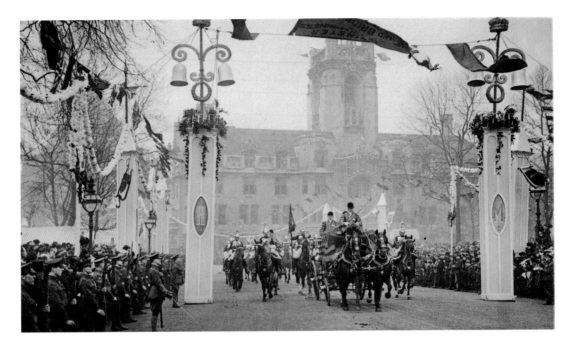

The Wedding of Viscount Lascelles, 6th Earl of Harewood, and Princess Mary, Westminster Abbey, 28 February 1922

Westminster Abbey has conducted numerous royal weddings through the centuries, this being the scene in Parliament Square following one of them. Princess Mary was the only daughter of George V. Among the couple's seven attendants was Lady Elizabeth Bowes-Lyon, who later married the Duke of York, the future George VI – she is fondly remembered as the much-loved Queen Mother. The glittering scene has a backdrop of the Middlesex Guildhall (1912–13). (*Postcard by unnamed photographer*)

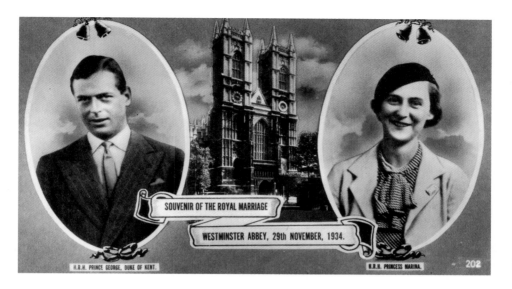

SOUVENIR OF THE ROYAL MARRIAGE

WESTMINSTER ABBEY, 29th NOVEMBER, 1934.

H.R.H. PRINCE GEORGE, DUKE OF KENT. H.R.H. PRINCESS MARINA.

The Marriage of Prince George, Duke of Kent, and Princess Marina of Greece and Denmark, Westminster Abbey, 29 November 1934

Prince George was the fourth son of King George V and Queen Mary. Princess Marina was the most recent foreign princess to marry into the royal family. The postcard commemorates another magnificent ceremony at the abbey, which is also seen below on a Victorian lantern slide. Almost unchanged from that time, both images show the abbey's mighty west front with the twin towers that were added to the medieval building from 1735 to 1745 by Nicholas Hawksmoor. (*Postcard by Excell Series*)

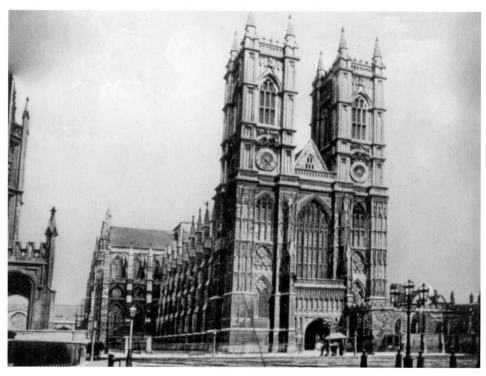

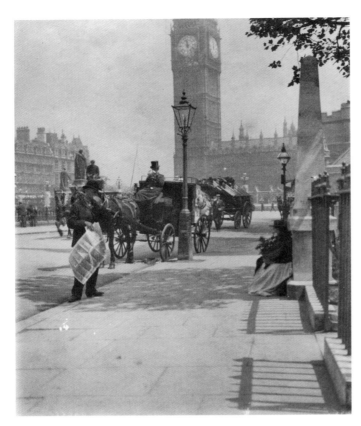

Outside Westminster Abbey, *c.* 1900
A snapshot of everyday street life in Victorian Westminster, with a cockney flower girl, a map seller, a four-wheel cab (growler), and a horse-drawn refuse cart. This scene was photographed by one of the tourists who frequent this part of London.
(*Tourist's snapshot*)

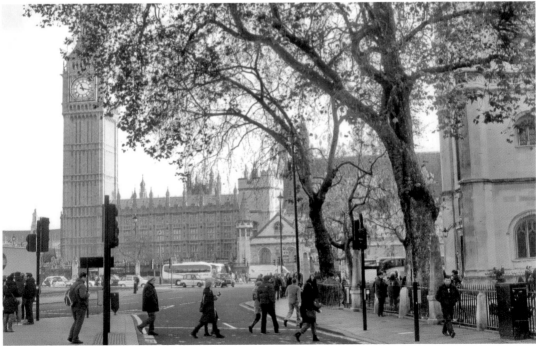

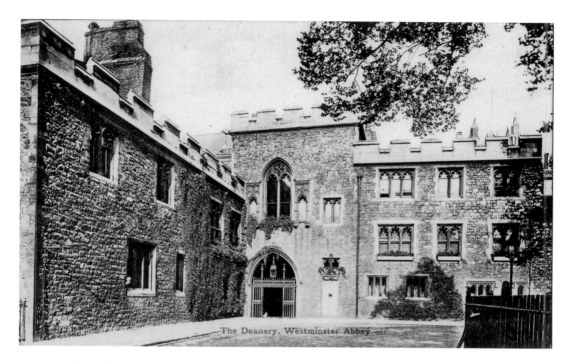

The Deanery, Westminster Abbey

Dean's Yard Westminster Abbey: The Deanery, Gatehouse and Cellarer's Building, *c.* **1908**
Dean's Yard is one of London's hidden gems. It is a large, leafy quadrangle bordered by a rich variety of historic buildings belonging to Westminster Abbey and Westminster School. The abbey's fourteenth- and sixteenth-century Deanery, with its age-blackened stonework, is seen on the left. The Gatehouse, also from the fourteenth century, is an entrance to the Great Cloister, and the Cellarer's Building (1388–91) is on the right. The abbey itself retains some stonework from the eleventh century. (*Postcard by unknown publisher*)

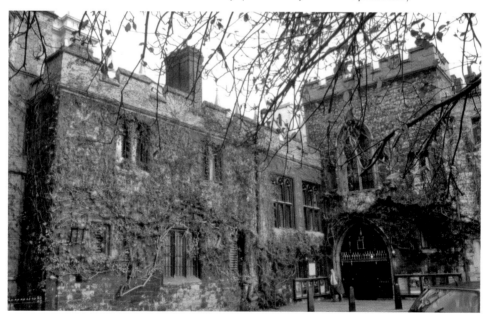

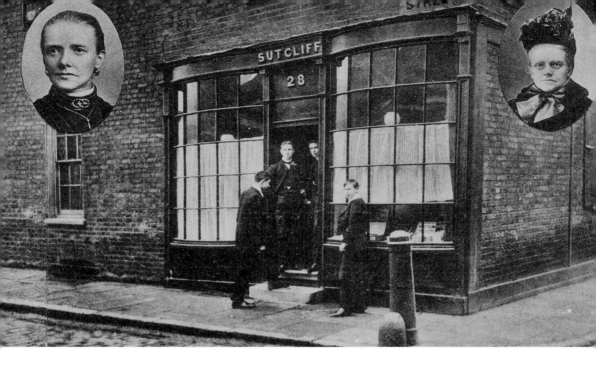

Westminster School: Tuck Shop, No. 28 Great College Street by Tufton Street, *c.* 1900
The ancient buildings of Westminster School – the oldest dating from 1090 – are grouped along and behind Dean's Yard, the former monastic quarters of Westminster Abbey. Ever popular among Westminster's schoolboys was the tuck shop, run by Miss Harriet Sutcliffe who is portrayed here in 1880 and 1911. The shop was demolished in 1903. (*Postcard by Westminster School Series*)

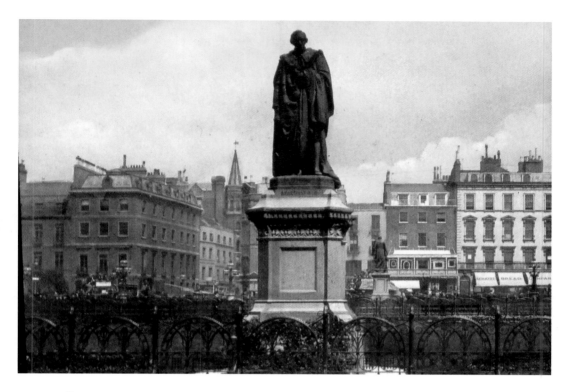

Parliament Square, *c.* 1895

This great square originated early in the nineteenth century with plans to sweep away an old slummy area and give the Palace of Westminster and Westminster Abbey a more dignified setting. The initial design was by E. M. Barry in 1868, with alterations following at regular intervals including the erection of a variety of statues of prominent figures. The statue in the picture is of Benjamin Disraeli, Earl of Beaconsfield – it was unveiled in 1883. The shops and houses visible in the background that ran between Parliament Street, King Street (left of statue) and Great George Street were removed in 1898. Edwardian government offices now occupy the site. (*Lantern slide by unnamed photographer*)

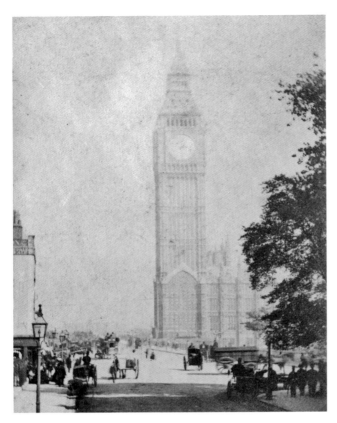

The Clock Tower (Big Ben) from Parliament Square, *c.* **1865**
The lower part of the clock tower is seen here in an unfamiliar condition. It had been left unfinished while awaiting a projected wing enclosing New Palace Yard that was later abandoned, and the tower has remained in the condition we know today. The projecting building on the left was the Mitre & Dove tavern at the entrance to King Street, part of the old residential district that ran back almost to Horse Guards Parade. The grandiose government buildings here now were put up between 1899 and 1915. (*Unnamed photographer*)

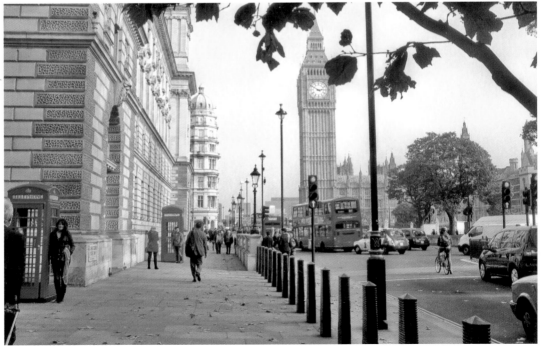

The Palace of Westminster from Parliament Square, with the World's First Traffic Light, *c. 1868*

The classic vista of the Palace of Westminster was revealed in 1860, with the removal of a row of houses along Bridge Street (left). This image, however, is remarkable for its depiction of the contraption on the traffic island – it was the world's first traffic light. This was a gas-powered revolving lantern, with red and green glass panels, set on a 22-foot, cast-iron pillar and operated by a pair of policemen, one of whom was injured when the device exploded in January 1869. The experimental apparatus was removed in 1872 and a further half century elapsed before mechanical traffic control was tried again. (*Stereo card by unnamed photographer*)

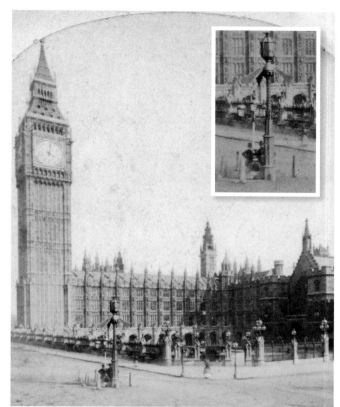

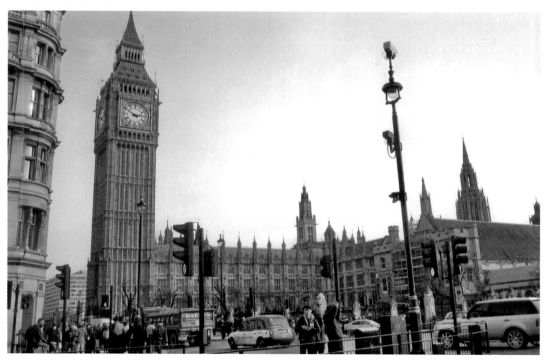

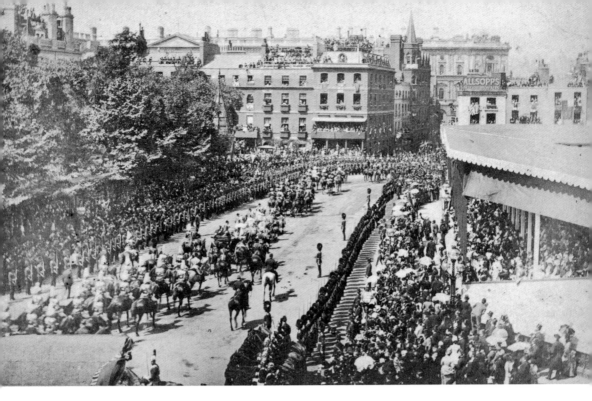

Queen Victoria's Golden Jubilee, Parliament Square (West Side), June 1887
Overlooked by Westminster Abbey and the Houses of Parliament, Parliament Square has witnessed many scenes of royal pageantry, including coronations, royal weddings and jubilees. This cabinet photograph shows the scene as Queen Victoria leaves Westminster Abbey following a service of thanksgiving for her Golden Jubilee. The centre of Parliament Square (right) had been set up with viewing stands, and the distant rooftops of houses in Great George Street were thronged with onlookers with a head for heights. Historic King Street is also visible, which once boasted three pubs. (*Photograph by the London Stereoscopic Company*)

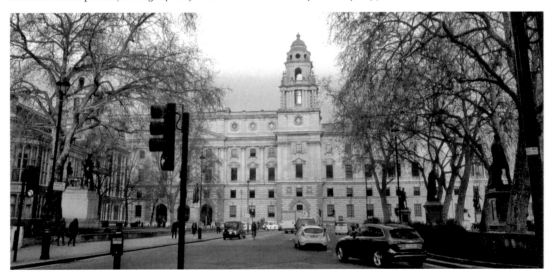

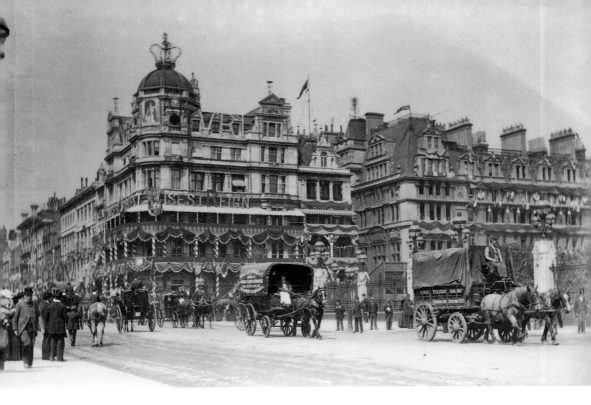

Queen Victoria's Diamond Jubilee, Parliament Square, June 1897
Ten years later, the Queen's Diamond Jubilee brought another wave of patriotic fervour to the capital and the nation. Her Majesty's Service of Thanksgiving took place at St Paul's Cathedral and much of London was decked out with colourful displays. New-style electric lights were used in Parliament Square, which included a crown lit by electricity above the domed corner turret of the London & North Western Railway building at the Bridge Street corner. (*From a Victorian photograph album*)

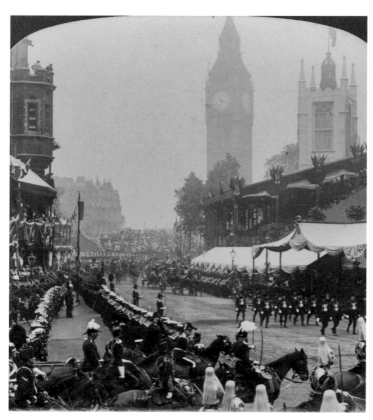

The Coronation of Edward VII and Queen Alexandra, Westminster Abbey, 9 August 1902 Coronations have taken place at Westminster Abbey since 1066, a year in which two kings were crowned: Harold II and William I (William the Conqueror). Edward VII's spectacular coronation procession was pictured on this stereoscopic image showing the King's Bargemen passing the abbey. The view includes St Margaret's Westminster, the parliamentary church, the origins of which date back to the eleventh century. (*Stereo card by H. C. White & Co.*)

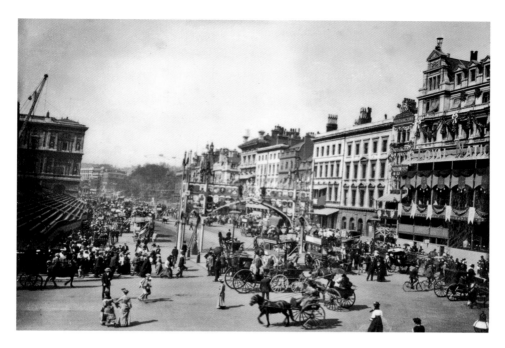

Parliament Street and Whitehall from Parliament Square, 1902
One of the widest streets in London, Parliament Street with Whitehall originated as a much narrower route between Charing Cross and Westminster until the removal of King Street brought about the spacious thoroughfare we know today. This snapshot pictures the scene at coronation time in 1902, with the colourful ceremonial arch and viewing stands on the site of King Street (left). The houses visible centre right were part of Parliament Street's eighteenth-century development. (*Amateur snapshot*)

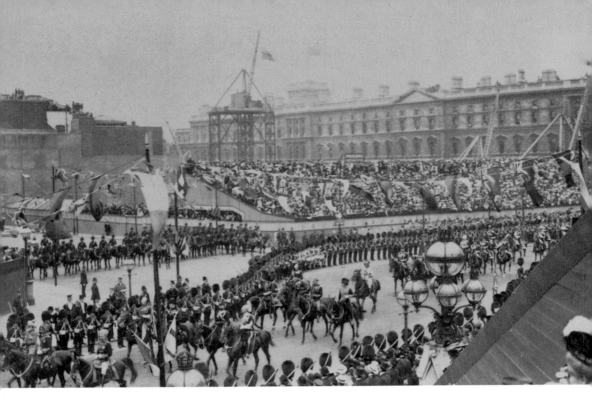

The Coronation of Edward VII, Parliament Square, 1902

Parliament Square's spaciousness has been emphasised here by the removal of properties on its northern side, allowing a clear view of the Foreign, Colonial and India offices in Charles Street. The empty site also gave space for coronation viewing stands, but new government offices would soon rise bearing the Royal Cypher of the new King, E VII R. (*From an Edwardian photograph album*)

Building the Coronation Arch, Parliament Street by Parliament Square, 1902
The royal route from Buckingham Palace to Westminster Abbey passed through this temporary ceremonial arch, embellished with colourful coats of arms. Ahead lay the abbey, whose twin towers were an impressive sight. In the present day the scene is dominated by one of the subway entrances to Westminster Underground station, which had opened as 'Westminster Bridge' in 1868 – the subway entrances were later innovations. (*Amateur snapshot*)

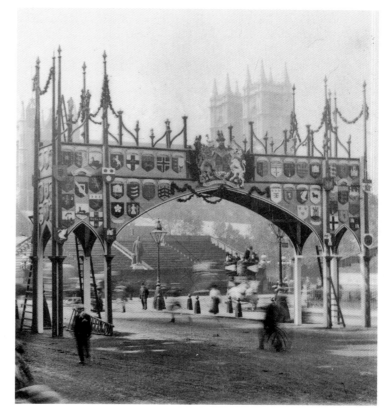

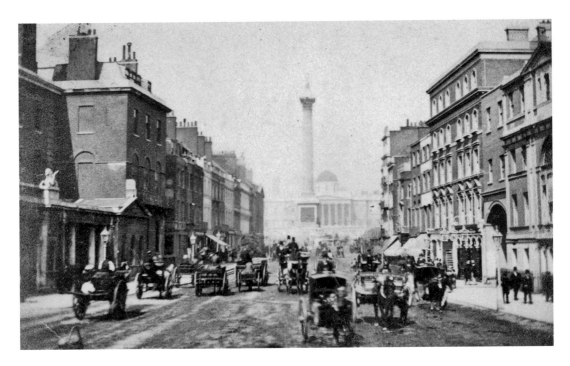

Charing Cross from Whitehall, *c.* 1865

Steeped in governmental, military and royal history, Whitehall and its tributaries are at the heart of British government. This *carte-de-visite* shows the street's narrower section, leading to Charing Cross and Trafalgar Square. To the left are the eighteenth-century buildings of the Admiralty, with small-scale shops and houses beyond. The covered archway entrance to Great Scotland Yard is on the right; this is famed as the first headquarters of the Metropolitan Police (1829–30). The red-brick Clarence pub (1862) was enjoying the early years of its life. (*Carte-de-visite by Valentine Blanchard*)

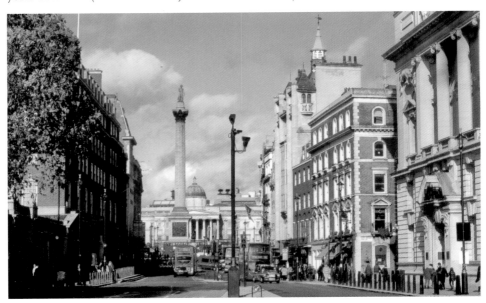

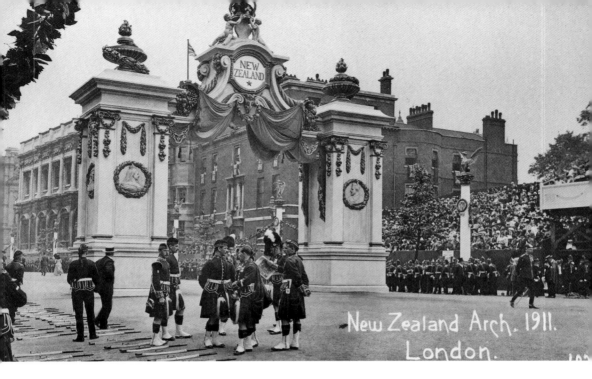

New Zealand Arch. 1911. London.

Coronation Day, Whitehall, 22 June 1911

An informal scene by the New Zealand Arch as Whitehall prepares for George V's coronation procession. Seen through the arch is Gwydyr House (1772), England's first Palladian building designed by Indigo Jones. This was an early stage in the projected rebuilding of Whitehall Palace, the origins of which reach back to the 1200s – it was the great royal palace of the Tudors and Stuarts. The palace was once the largest in Europe, reaching from the Thames to St James's Park where Henry VIII established a tilt yard for jousting at what is now House Guards Parade. (*Postcard by unnamed photographer*)

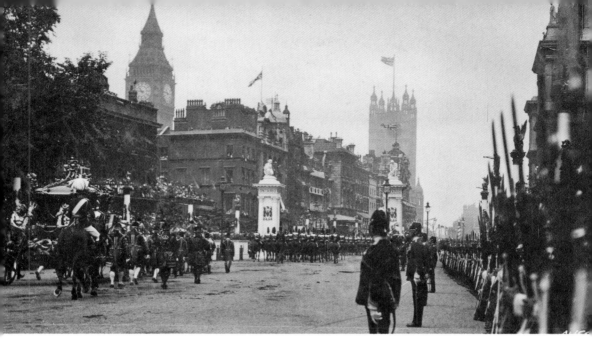

Coronation Day, 22 June 1911

The scene in Whitehall, as King George V and Queen Mary drive in procession to Westminster Abbey. Whitehall is famed for its military memorials, but this image predates the arrival of the Cenotaph in 1919, the national memorial to fallen wartime heroes. (*Postcard by Owers of Southsea*)

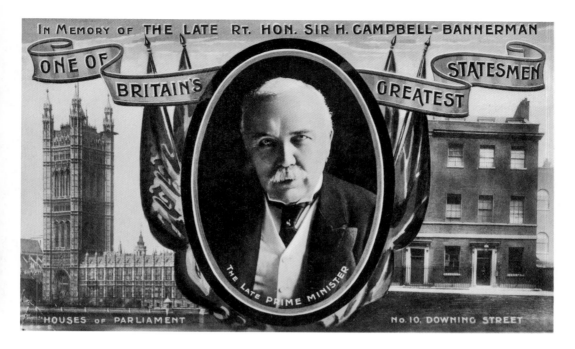

IN MEMORY OF THE LATE RT. HON. SIR H. CAMPBELL-BANNERMAN

ONE OF BRITAIN'S GREATEST STATESMEN

THE LATE PRIME MINISTER

HOUSES OF PARLIAMENT

No. 10. DOWNING STREET

Right Honourable Sir Henry Campbell-Bannerman, Prime Minister in the Liberal Ministry, 1905–08, & No. 10 Downing Street, Whitehall, 1908
This postcard commemorates the late prime minister who died in December 1908 and pictures one of London's most famous addresses, No. 10 Downing Street, the prime minister's official residence. The house and its neighbours Nos 11 and 12 are all that remain of the old residential street, which was first inhabited in 1683. Security gates from Whitehall were put up in 1990. (*Postcard by Rotary Series*)

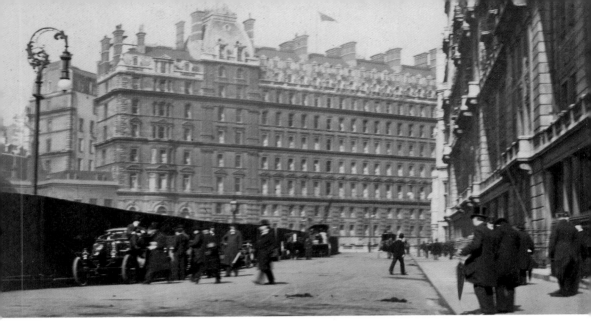

Whitehall Court from Horse Guards Avenue, 1901
The National Liberal Club and residential Whitehall Court date from the 1880s, as does the Hotel Metropole, which closes the view. The empty site on the left was awaiting the arrival of the Ministry of Defence's (old) War Office, which was finished in 1906. The photograph also shows one of the meetings of early motoring enthusiasts who regularly gathered here. (*Amateur snapshot*)

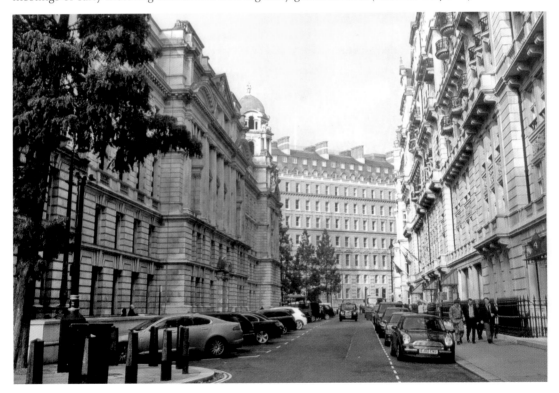

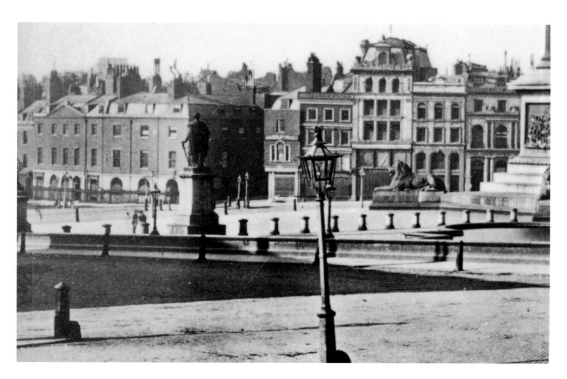

Charing Cross and Spring Gardens, from Trafalgar Square, *c.* 1870
This was the scene before the arrival from 1908 to 1911 of one of London's great landmarks, Admiralty Arch, and its redesigned approach to The Mall. The terraced houses on the left by Spring Gardens dated from the 1740s and included Drummond's Bank; they were demolished in 1877 but the bank lives on in rebuilt premises. (*Unnamed photographer*)

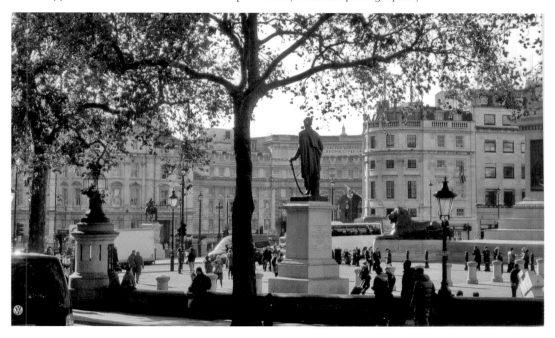

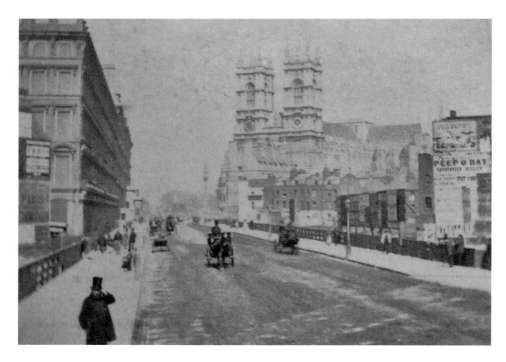

Westminster Abbey from Victoria Street, *c.* 1865
Taking its name from the monarch, Victoria Street was a new thoroughfare dating from 1847 to 1851, which cut through old run-down neighbourhoods. It was not until the 1890s that the street was finally lined with new buildings. This stereoscopic view shows an early stage in the street's life, with unfilled building sites and ragged remnants of old properties in Dean Street (Great Smith Street); Westminster Palace Hotel (1861) was an early arrival. Post-war rebuilding brought little to enhance the approaches to one of this nation's most historic landmarks. (*Stereo card by unnamed photographer*)

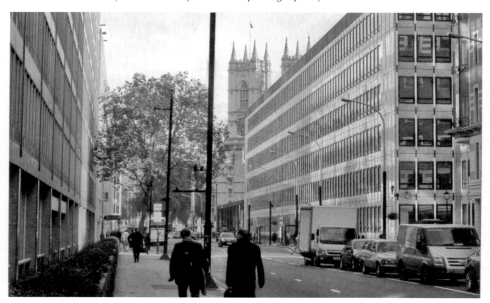

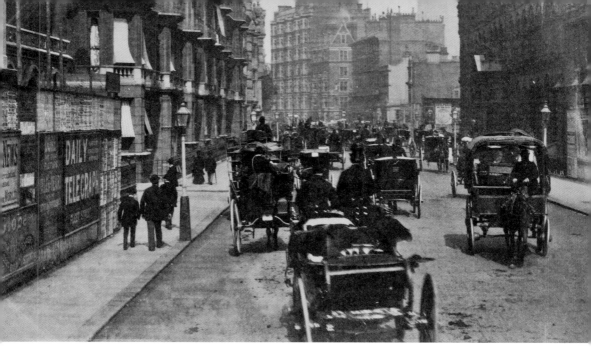

Victoria Street by Artillery Row, *c.* 1898
The new street soon brought a new style of London living with blocks of smart mansion flats, the first of which arrived in 1854. Queen's Mansions are seen here with Marlborough Mansions (1885) and Artillery Mansions (1895). Much property in Victoria Street was rebuilt in post-war years but concrete office blocks brought drabness until further rebuilding introduced a far more appealing style of modern architecture. (*Unnamed photographer*)

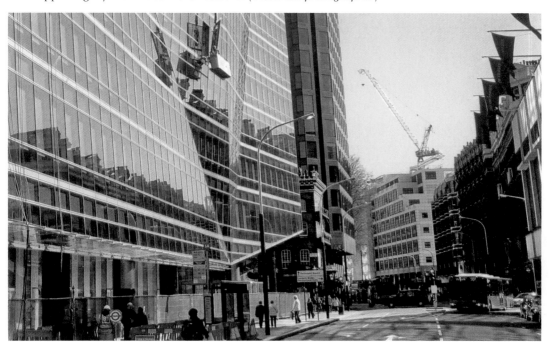

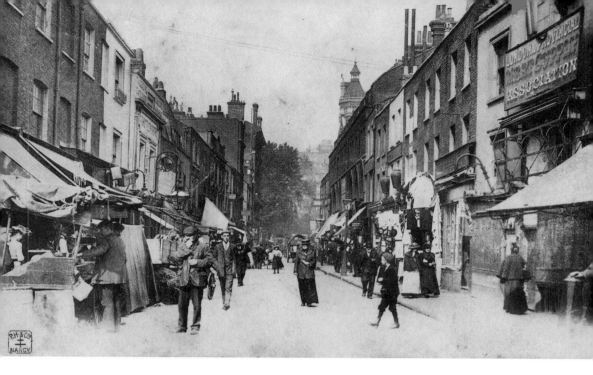

Strutton Ground, Victoria Street, c. 1905

The northern part of Strutton Ground was swept away with the cutting through of Victoria Street, but the remaining section represents a rare survival of a lost neighbourhood. Strutton Ground was built up from around 1616, and it continues to host a traditional cockney street market. There was also a cinema at No. 30, which lasted from around 1912 to 1931. (*Postcard by P. H. & Cie, Nancy, France*)

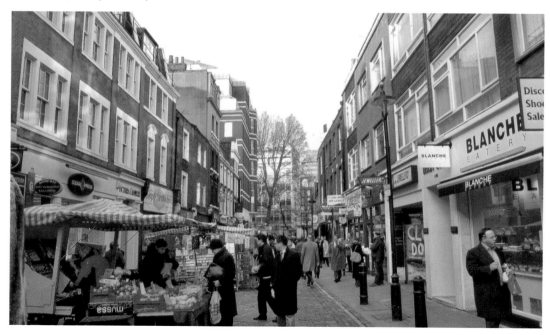

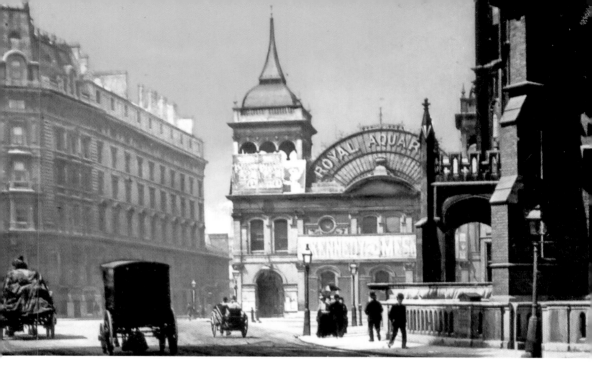

The Royal Aquarium from Broad Sanctuary, Storey's Gate, *c.* 1895

This palm-filled entertainment venue did not fulfil its owner's hopes of success, despite its skating rink, fish tanks and music hall theatre. Built in 1876, it soon gave up its site for the Methodist church's central hall (1905–11). Westminster Hospital occupied the building on the right from 1834, until its removal to Horseferry Road in 1939 cleared the way for the Queen Elizabeth II Conference Centre, built between 1981 and 1986. (*Lantern slide by unnamed photographer*)

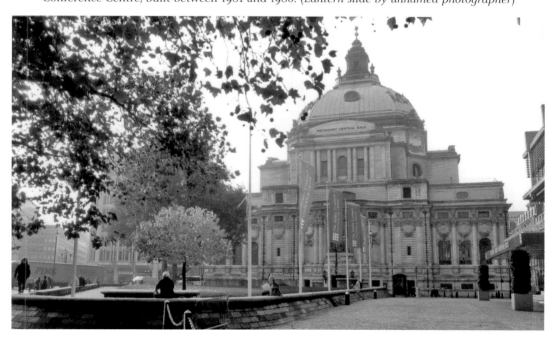

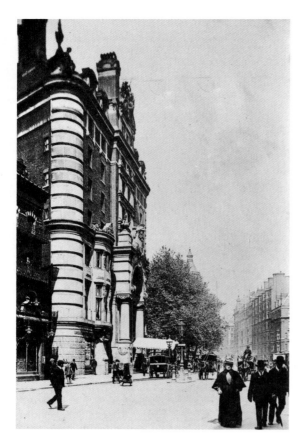

Hotel Windsor, Victoria Street by Palmer Street, *c.* 1906
Deliciously derided by Pevsner as 'the crowning monstrosity of Westminster' and 'a nightmare of megalomaniac decoration', the Hotel Windsor made an eye-catching spectacle. This elephantine composition was the work of architect F. T. Pilkington and was built between 1881 and 1883. A saner world existed next door with the restrained Albert pub (1862), but when an office block arose on the old Windsor site, it cost London one of its more quirky buildings. (*Postcard by A. & G. Taylor's Reality Series*)

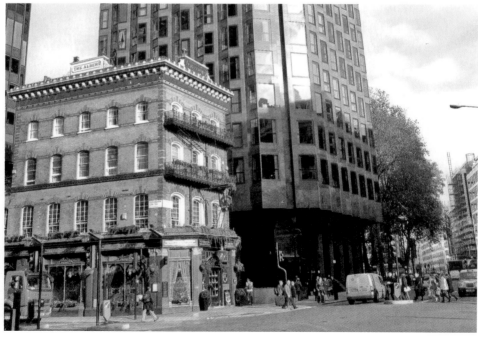

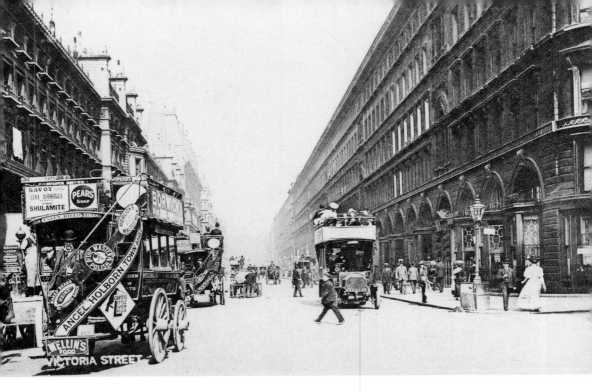

Victoria Street near Carlisle Place, *c.* 1906
Impressive, if monotonous, ranges took up parts of the new street, but among them was a noted department store, the Army & Navy, which emerged in 1872 and was rebuilt between 1973 and 1977. The image shows how new motorised buses were beginning to oust the old horse-drawn variety in Edwardian London. (*Postcard by A. & G. Taylor's Reality Series*)

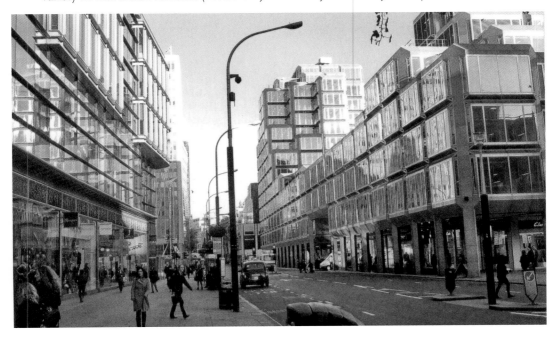

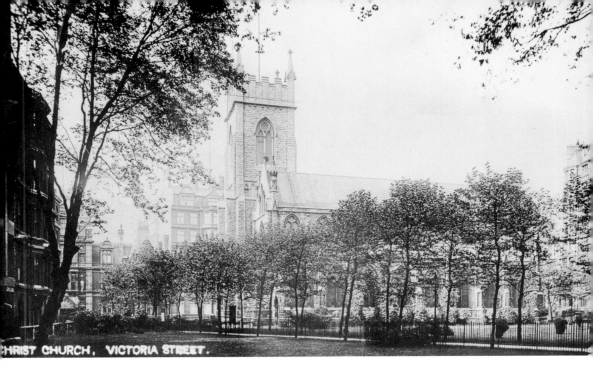

CHRIST CHURCH, VICTORIA STREET.

Christ Church, Broadway, from Victoria Street, *c.* 1906
Built in 1847 on the site of the Broadway chapel, Christ Church, as designed by Ambrose Poynter, was lost to wartime bombing. A telephone exchange arose on the site from 1959. The old church's burial ground remains in place, however, giving a welcome touch of greenery in the midst of Victoria Street's intensely urban reaches. (*Postcard by A. & G. Taylor's Reality Series*)

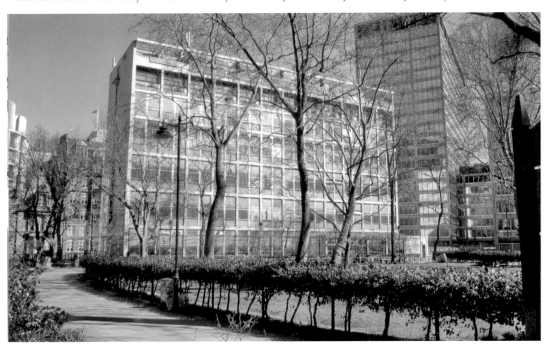

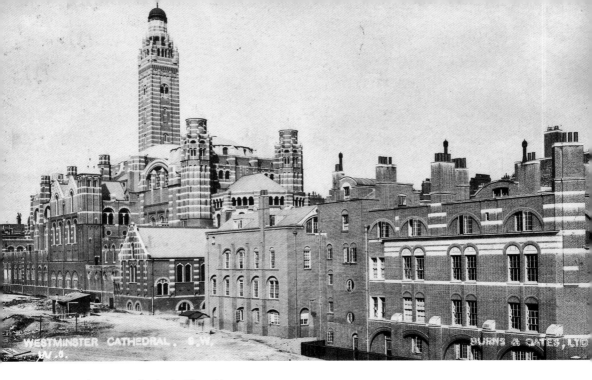

Westminster Cathedral When New, *c.* 1905

Westminster's Roman Catholic Cathedral towers high above a site which, until 1877, was occupied by the Middlesex House of Correction, Westminster Bridewell. Byzantine in style, the cathedral was designed by J. F. Bentley and was begun in 1895 – consecration took place in 1910. It now sits in a district of smart mansion flats, but the precincts of the cathedral are seen here in an unfinished state. (*Postcard by Burns & Oates Ltd*)

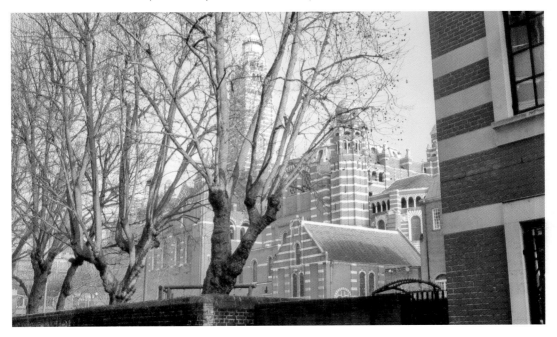

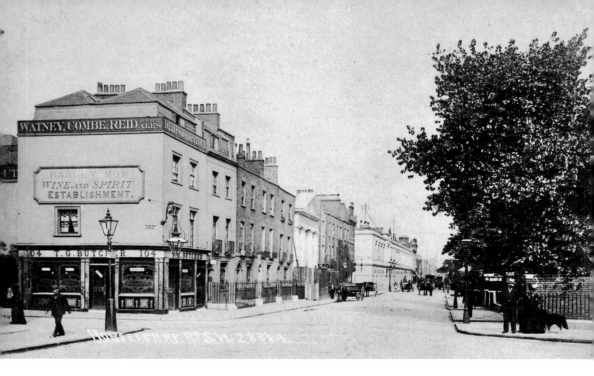

Horseferry Road by Arneway Street, *c.* 1906

An old ferry transported horses across the Thames before the building of Lambeth Bridge; Horseferry Road was the street that led to it. This was once a slummy area and a pioneering gasworks by Monck Street added its own aroma to the district. Following the clearance of old worn-out properties, handsome new ones arose in their stead, although a few reminders of former times have survived, including part of the terrace shown here. The Barley Mow pub has since been rebuilt, however, and a new Westminster Baptist church dates from 1934. (*Postcard by John Walker & Co.*)

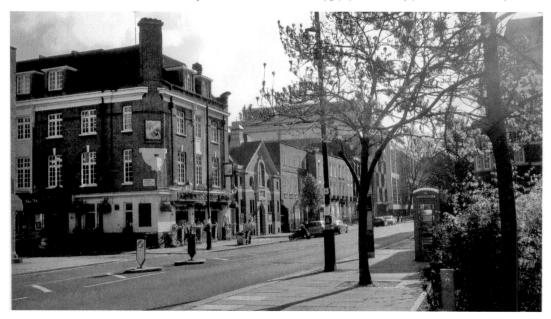

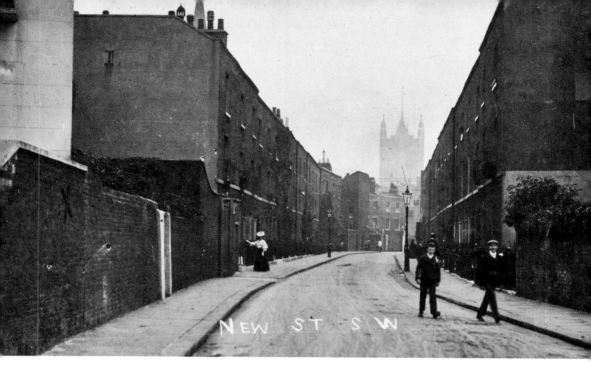

New Street (Maunsel Street) from Vincent Square, *c.* 1906
This remains an almost complete street of houses from the 1820s in one of Horseferry Road's old residential neighbourhoods. The houses were modest in scale but have been gentrified into highly desirable town houses enjoying a fine view of the Palace of Westminster's Victoria Tower. The street name changed in the 1930s when a plethora of 'New Streets' were renamed. (*Postcard by unnamed photographer*)

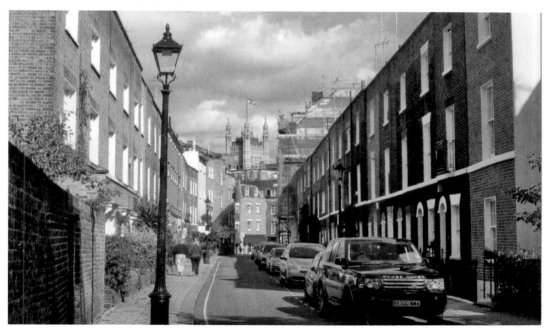

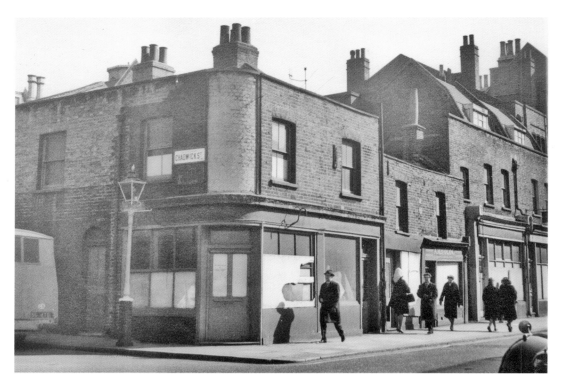

Horseferry Road by Chadwick Street, 1964
An example of the run-down properties that still blighted parts of Horseferry Road in post-war years. Demolition soon followed here and in 1991 the eye-catching Channel 4 Television Headquarters were built. A garden at the rear contains a plaque recalling Westminster College (1851), which once stood there. (*Photograph by the author*)

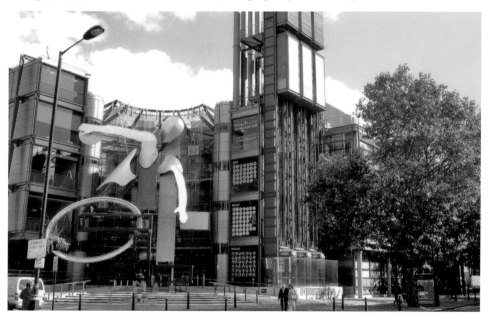

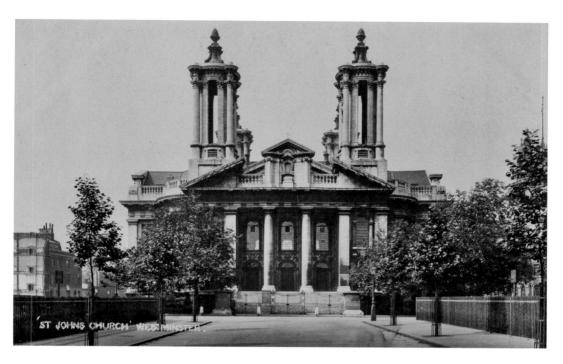

St John's, Smith Square, *c.* 1909

Baroque in style, the church was designed by Thomas Archer and built between 1713 and 1728. It was wrecked by fire in 1941 but revived as a concert hall in later years. The church's south front is seen from Dean Bradley Street, a new link from Horseferry Road to Smith Square that was created around 1908 – its building sites were still empty when photographed here. (*Postcard by unnamed photographer*)

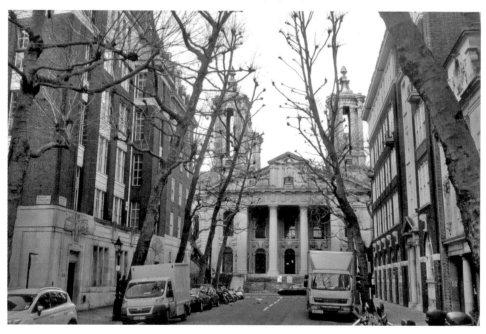

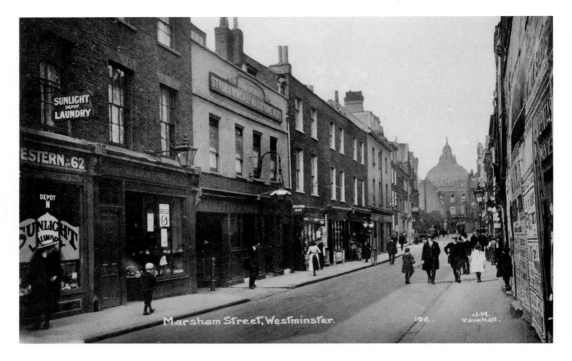

Marsham Street from Horseferry Road, *c.* 1910

The Edwardian face of an old street in Westminster lined with domestic stores and pubs. The Rose & Shamrock pub is visible and Loud & Western's Sunlight Laundry remains a familiar name. The clearance of Marsham Street and a large adjoining site containing the world's first gasworks (1812) made way for the hideous Department of the Environment Building (1963–71), whose merciful demolition led to a new Home Office building in 2004. The Methodist Central Hall closes the view. (*Postcard by J. M. Vauxhall*)

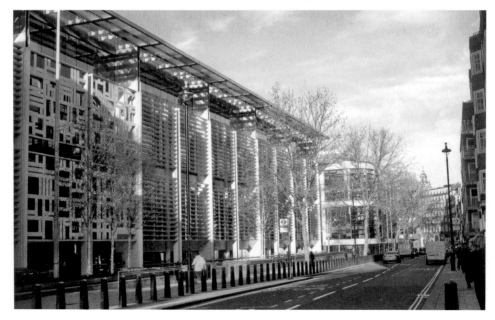

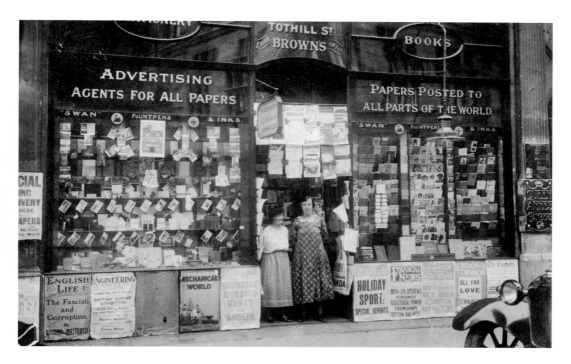

Arthur Brown, Advertising Agent, Newsagent, Stationer and Bookseller, Queen Anne's Chambers, Tothill Street, 1924
Founded in 1810, this was a popular and long-standing business that had many decades of life ahead of it when photographed here. The shop windows were well-stocked with a range of postcards, including comic ones of 'Bonzo the Dog' and a selection of London views. (*Postcard by unnamed photographer*)

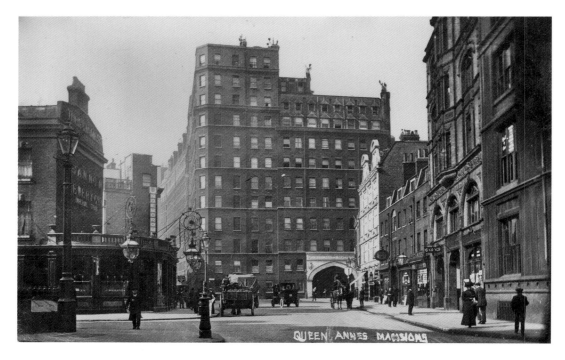

Broadway from Tothill Street, *c.* 1910
The changes of a century are evident here with the lofty Queen Anne's Mansions (1889) replaced by the Home Office Building of 1972–76. Another new landmark arose in 1929 when Charles Holden's, No. 55 Broadway, the headquarters of London Underground, replaced old St James's Tavern (left). The new building cleverly included a rebuilt St James's Park Underground station, replacing the brick-built facility which had opened in 1868. (*Postcard by unnamed photographer*)

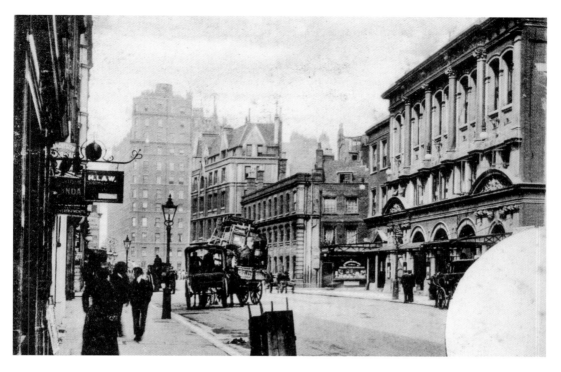

The Imperial Theatre, Tothill Street by Dartmouth Street, *c.* 1903
Once part of the entertainments complex of the Royal Aquarium, the Imperial opened in 1876 as the Royal Aquarium Theatre, a largely unsuccessful venture. The theatre was closely associated with the actress and mistress of King Edward VII Lillie Langtry, but despite a rebuilt interior it finally closed in 1907. (*Printed postcard by unnamed publisher*)

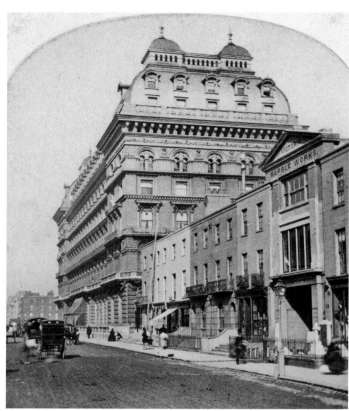

The Grosvenor Hotel, Buckingham Palace Road, *c.* 1862

The street bears an illustrious name, but in former times the reality did not always live up to it. In this early view there were modest terraced houses, shops and an archway entrance to the Victoria Marble and Stone Works. Stone was once carried on barges from the Thames to this point via the Grosvenor Canal. This followed the line of the railway into Victoria station, the site of which was once the canal's terminal basin. Seen here is the brand new Grosvenor Hotel (1860–62), the first of London's great Victorian railway hotels. (*Stereo card by the London Stereoscopic & Photographic Co.*)

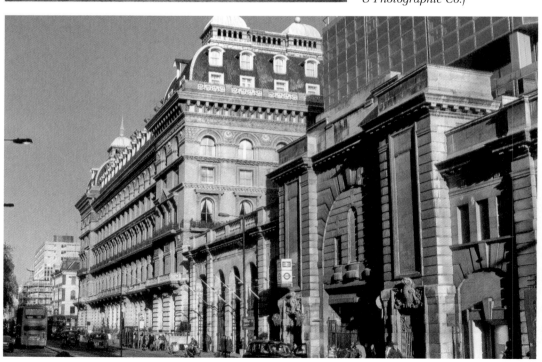

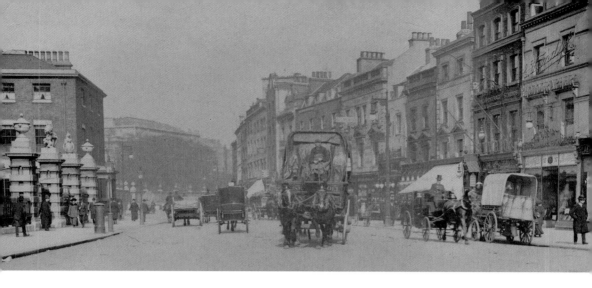

Buckingham Palace Road from Lower Grosvenor Place, *c.* 1905 and *c.* 1920
Only fifteen years separate the two images but this was time enough for the Hotel Rubens to replace the row of small shops that included the studios of photographers Carl Vandyke at No. 37 and Jas Langton next door. The left sides of the photographs are taken up with parts of Buckingham Palace including the entrance to the Royal Mews (1822–25), as built by John Nash following the displacement of the Mews from its old site at Trafalgar Square. (*Postcards by John Walker & Co., and Messrs Degen & Lewis*)

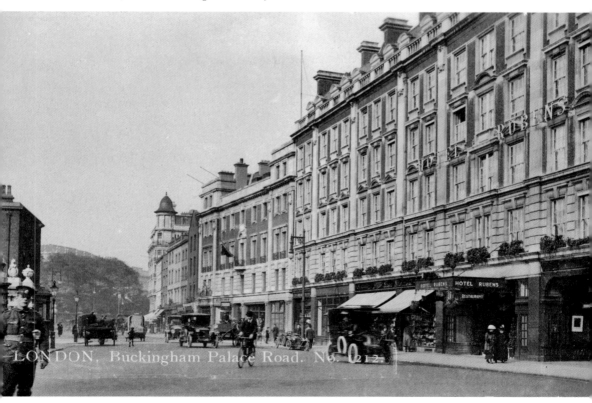

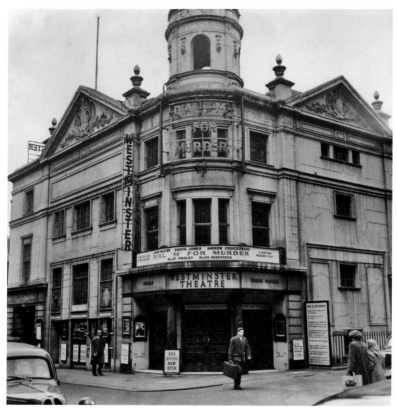

Westminster Theatre, Palace Street, *c*. 1952 This was a conversion of an eighteenth-century chapel and opened in 1924 as the St James's Picture Theatre. The cinema lasted until 1931, after which it staged plays by Tyrone Guthrie, Ibsen and J. B. Priestley, among others. Fire destroyed the theatre in 2002 but it has risen again as the St James's Theatre. (*Unnamed photographer*)

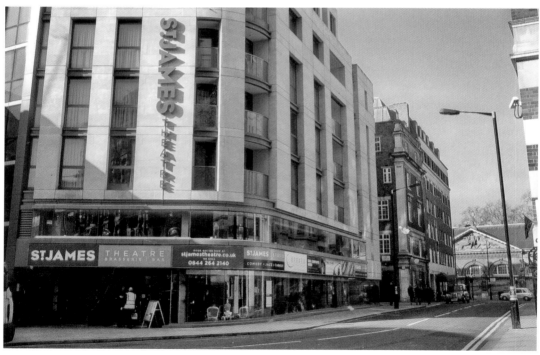

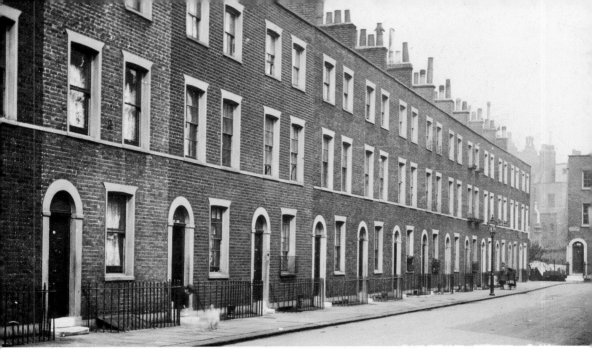

Catherine Street (Catherine Place), *c.* **1907**
This was part of a small neighbourhood of modest town houses close to Buckingham Palace. These examples were built around 1810–20. In the Edwardian photograph they had retained much of their original appearance, but a century later they were unrecognisable with new builds and drastic updates. (*Postcard by A. & G. Taylor's Reality Series*)

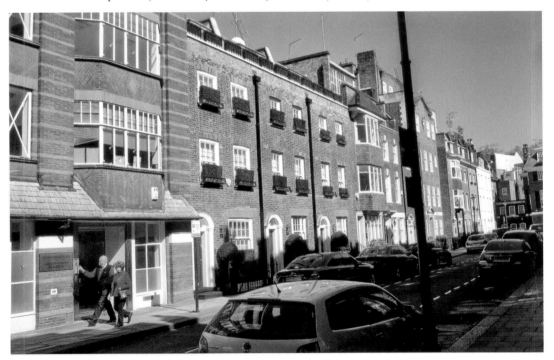

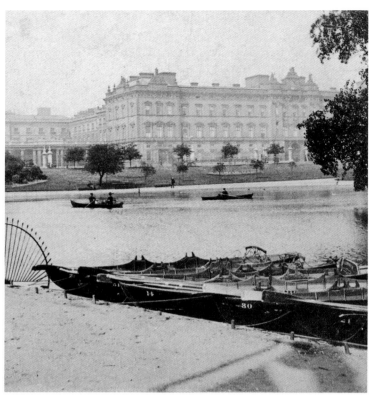

Buckingham Palace from St James's Park, c. 1890
Buckingham Palace is famed worldwide as the London residence of the monarch. It developed out of Buckingham House (1702–05), the residence of the Duke of Buckingham, and was transformed into a royal palace by Nash to replace Carlton House. Queen Victoria was the first monarch to live there. The palace is seen beyond St James's Park lake in the days when the public were permitted to disturb the abundant waterfowl with boating. (*Stereo card by B. W. Kilburn*)

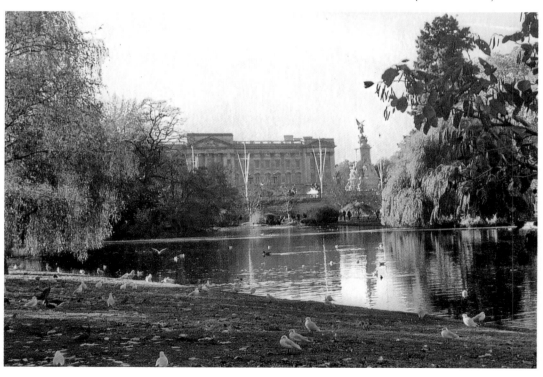

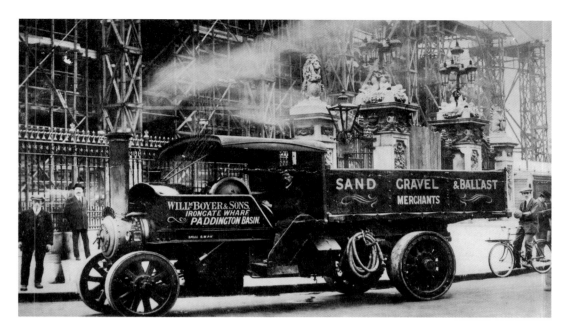

Building a New Façade for Buckingham Palace, 1913
Work is in progress, replacing Edward Blore's original façade with a new design in Portland stone by Sir Aston Webb. The project was completed in three months and bore similarities to the new Admiralty Arch, which was also by Sir Aston Webb. The image is from a publicity postcard issued by sand, gravel and ballast merchants William Boyer & Son, who supplied building materials for the project. (*Photographed by Ernest Milner*)

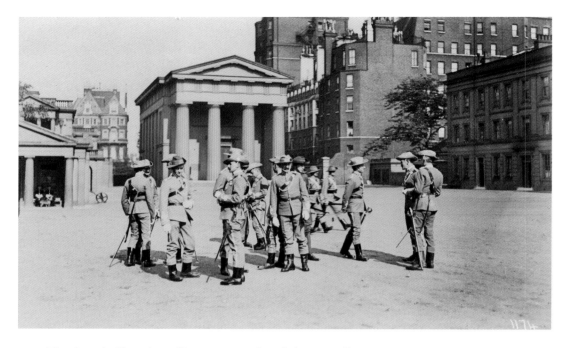

The Guards Chapel, Wellington Barracks, Birdcage Walk, *c.* 1906
Frequently the scene of colourful military spectacles, the spacious parade ground is bordered by long ranges of stuccoed barracks dating from 1833 to 1834. The Guards Chapel was characterised by its massive Doric columns, but the building was the scene of a dreadful wartime tragedy when it received a direct hit from a flying bomb during Divine Service in 1944 – 121 lives were lost. The rebuilt chapel, a design by Bruce George, incorporated surviving parts of the old building and opened in 1963. (*Postcard by G. W. Secretan*)

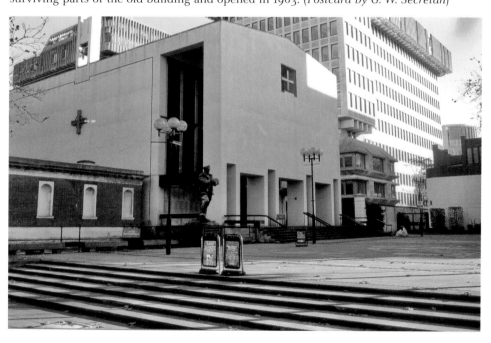

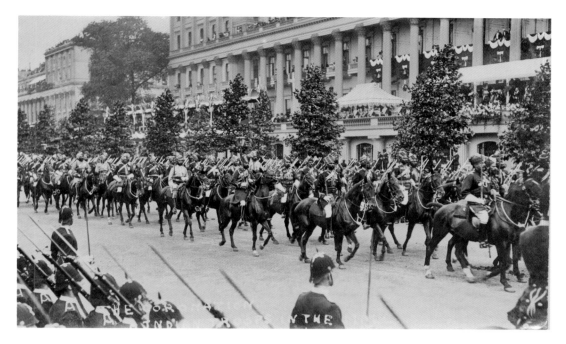

Carlton House Terrace from The Mall, Coronation Day, 22 June 1911
The Mall, London's great ceremonial route, originated as a Pall Mall alley around 1660; 'Pall Mall' was a fashionable ball game. The opening of Admiralty Arch in 1910 enhanced The Mall's role as a grand approach to Buckingham Palace, the entry into Trafalgar Square having previously been blocked by buildings. The monumental Carlton House Terrace was to the design of John Nash and put up on the site of Carlton House, the palace of the Prince Regent. (*Postcard by A. Barratt*)

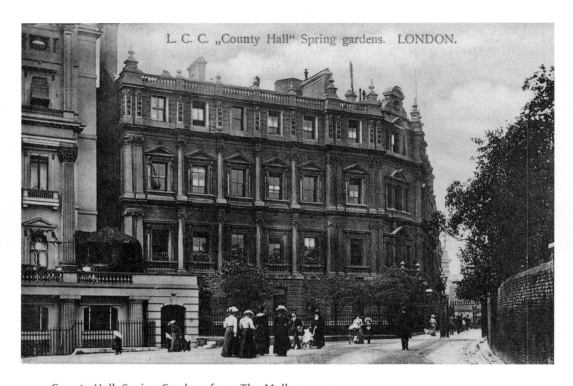

L. C. C. „County Hall" Spring gardens. LONDON.

County Hall, Spring Gardens from The Mall, *c.* 1903
London County Council's first County Hall was the centre of the city's government from its inception in 1889 to 1922, when a new County Hall opened beside the Thames at Westminster Bridge. The wall and gardens on the right were at the rear of the houses in Spring Gardens, the future site of Admiralty Arch. (*Postcard by Hartmann*)

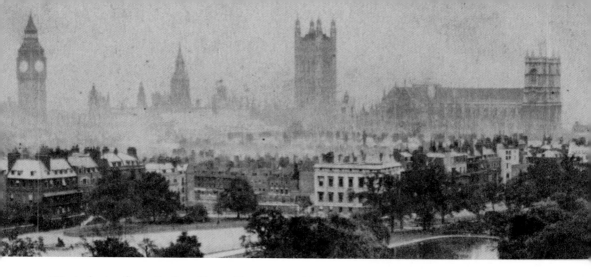

Westminster from Carlton House Terrace, *c*. 1860

The familiar landmarks of Westminster take up the skyline, but in front of them is a long-lost area of residential streets lined by plain-fronted Georgian houses. Among these are: King, Duke, Gardiner and Crown Streets, as well as Downing Street with the official residence of the prime minister at No. 10. Numbers 10, 11 and 12 are all that remain on this street. The old street pattern was lost from around 1863 as grandiose stone-fronted government blocks arose, including Gilbert Scott's Foreign Office, which took the site of the prominently seen State Paper Office (by Sir John Soane, 1834). A row of houses in Duke Street that backed onto St James's Park was a further casualty. (*Stereo card by unnamed photographer*)

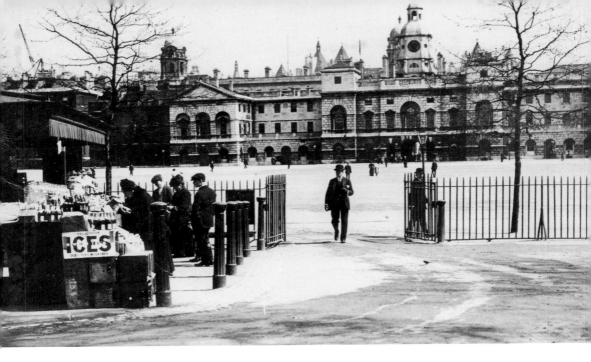

Horse Guards Parade, *c.* 1906

This was once the tilt yard of old Whitehall Palace, but it is now renowned worldwide as the setting for great military and royal spectaculars, including Trooping the Colour and Beating Retreat. The parade ground is overlooked by the historic buildings of the Horse Guards (1750–59). While these remain in a fine state of preservation, the foreground tells a different story, with its refreshment stand called 'The Tin Cow'. The Guards' Monument was erected on the site in 1926. (*Postcard by A. & G. Taylor's Reality Series*)

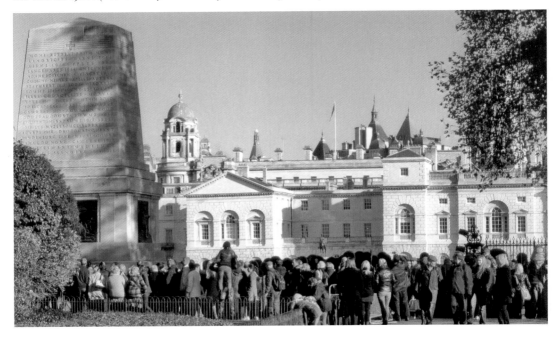

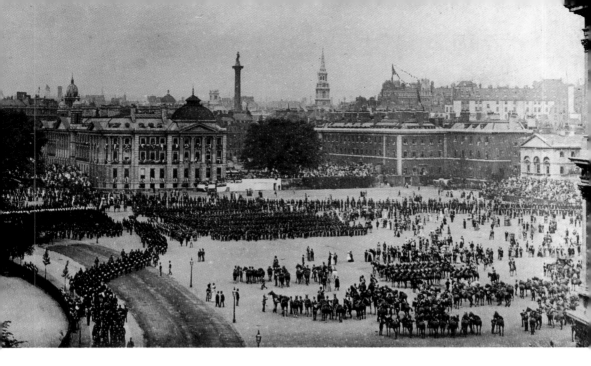

Horse Guards Parade, Looking North-East, *c.* 1903
The great parade ground has an unfamiliar look here, with a large gap that would later be filled by the completion of the Admiralty Extension in 1905. (*Postcard by unnamed photographer*)

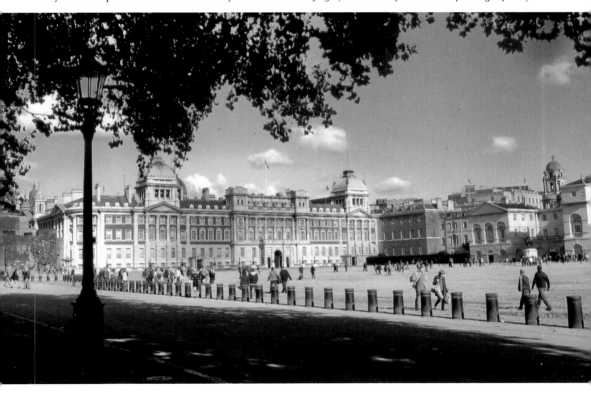

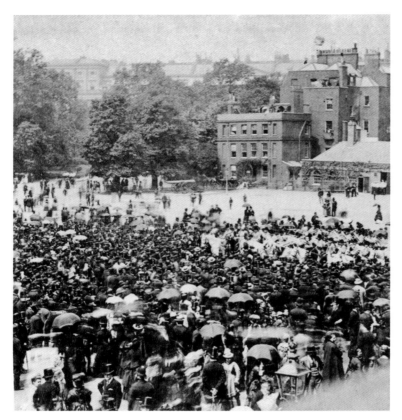

The Queen's Birthday, Horse Guards Parade, *c.* 1870
An earlier view of the parade ground, with the Admiralty's Gun House and the houses of New Street and Spring Gardens further back. The corner of Horse Guards Road has been marked since 1939 by the massive Citadel, a bombproof fortress for the Admiralty's communications rooms. Its image is now softened by abundant Virginia creeper. (*Stereo card by the London Stereoscopic Company*)

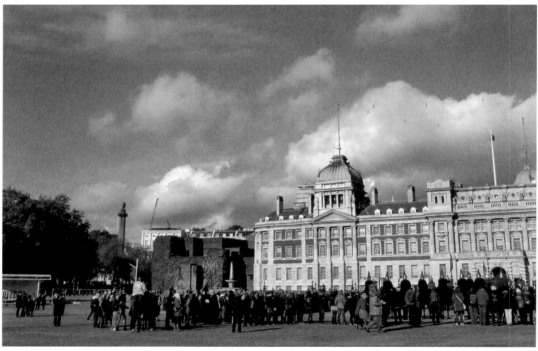

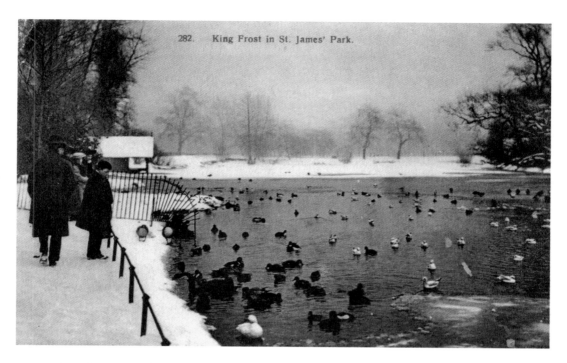

282. King Frost in St. James' Park.

Winter in St James's Park, *c.* 1908

St James's Park originated as a swampy field, which was cleared during the reign of Henry VIII for the creation of a deer park. The park has been altered many times through succeeding centuries and from the 1820s its principal water feature, a straight-sided canal, was beautified and given its present shape. St James's, the oldest of the royal parks, is noted for the variety of its bird life and for stunning views of the skyline of Whitehall Court and the National Liberal Club seen beyond Horse Guards Parade. (*Postcard by Hartmann*)

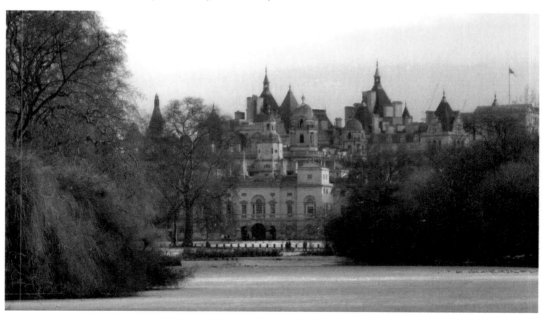

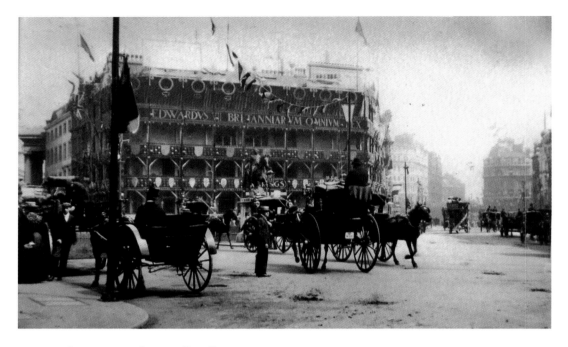

Cockspur Street from Pall Mall East, 1902

The Regency buildings are seen when decorated for Edward VII's coronation – there are viewing galleries offering fine views of the royal procession as it passed by. This would become the location for Oceanic House in 1906. The Cockspur name refers to the old royal pastime of cockfighting – this was one of the places where the birds' spurs were fitted before they were taken to the cockpits at Whitehall. There was also a royal cockpit at what is still called Cockpit Steps, off Birdcage Walk, St James's Park. (*From an Edwardian photograph album*)

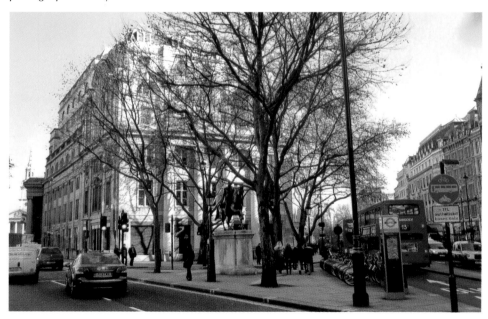

Her Majesty's Opera House, Haymarket by Pall Mall from Cockspur Street, *c.* 1865

This once elegant corner boasts a lengthy theatrical heritage, which has undergone many changes since the Queen's Theatre opened here in 1705. This was known as 'Her Majesty's' from 1837, and in 1878 Bizet's *Carmen* was performed for the first time in England. A new 'Her Majesty's' was built at Charles II Street in 1896–97, the old site making way for the Carlton Hotel. The equestrian statue of George III by Matthew Cotes Wyatt was erected in 1835. (*Carte-de-visite by unnamed photographer*)

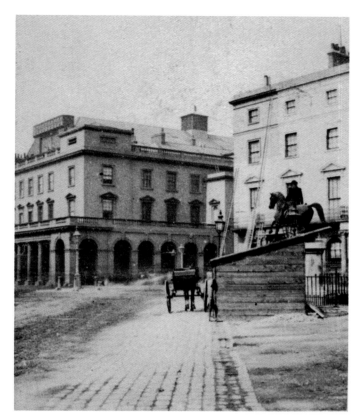

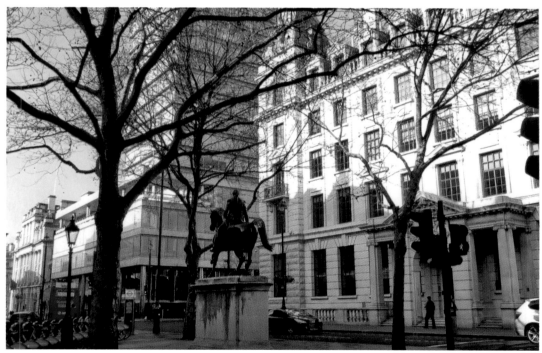

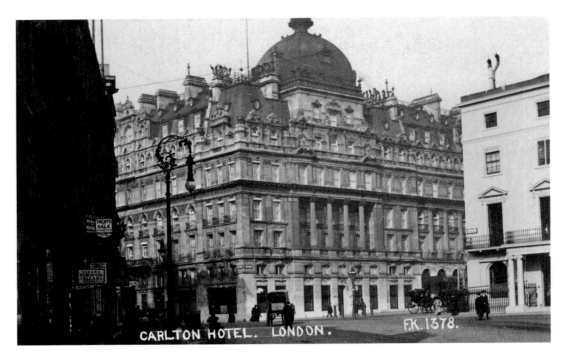

CARLTON HOTEL. LONDON. F.K. 1378.

The Carlton Hotel, Haymarket by Pall Mall, *c.* 1905
Adjoining the rebuilt Her Majesty's Theatre and matching it in splendid style, this hotel by C. J. Phipps opened in 1899. With César Ritz at the helm and Escoffier as chef, it was a magnificent establishment in London's West End. The hotel ceased business in 1939 and suffered wartime bombing, which led to demolition in the 1950s. The unattractive New Zealand House then arose on the site, its towering bulk ruining many views in this otherwise elegant townscape. (*Postcard by F. Kehrhahn*)

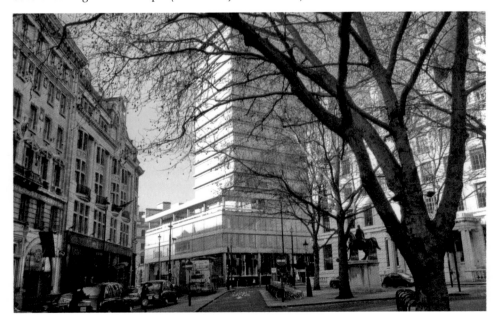

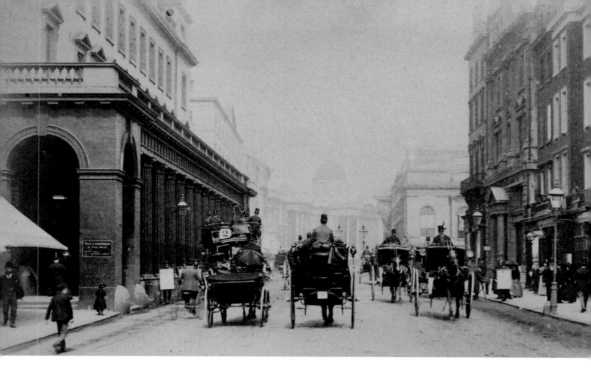

Pall Mall East, *c.* 1885
The view looks eastwards towards Haymarket and Trafalgar Square, offering a sight of the colonnade which adorned Her Majesty's Theatre. To the left is the entrance to Royal Opera Arcade, Britain's first dedicated shopping arcade which dates from 1816 to 1818. (*Mounted photograph by an unnamed photographer*)

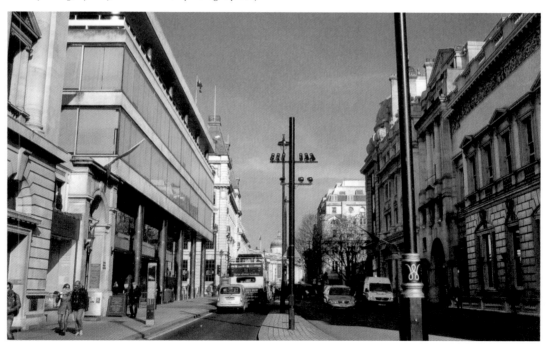

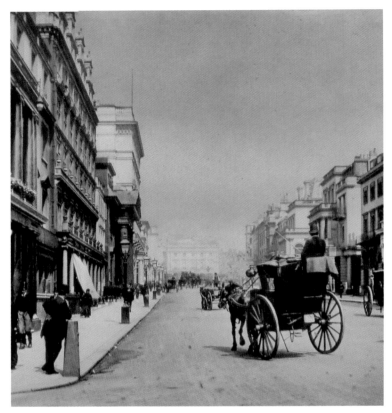

Regent Street from Charles Street, *c.* 1890
Sometimes called 'Lower' Regent Street, the St James's section of Nash's grand thoroughfare is seen when most of its original buildings were still in place, including the Grecian-style St Philip's chapel, the portico of which is seen projecting forward. The commercial Carlton House took its site in 1904, in the stone-fronted mode that ousted the stucco fronts of Nash's day. (*Lantern slide by unnamed photographer*)

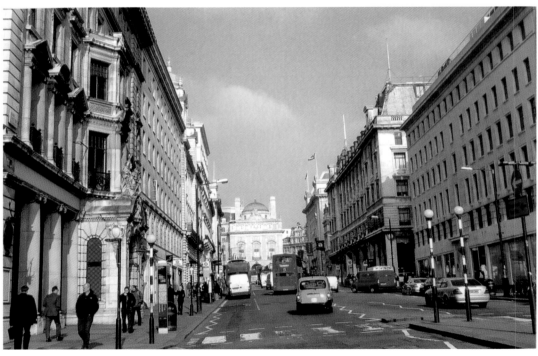

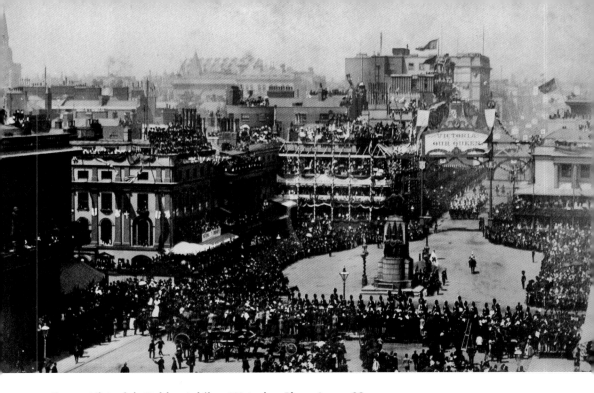

Queen Victoria's Golden Jubilee, Waterloo Place, June 1887
Although Queen Victoria reigned for over sixty years, she only celebrated two jubilees in that time; the projected rejoicing for her Silver Jubilee was cancelled due to the death of Albert, Prince Consort of Queen Victoria, in 1861. The Queen's Golden Jubilee in 1887 was, however, celebrated with great patriotic fervour throughout the land, nowhere more so than in London, where lavish decorations adorned streets and buildings. There was also a ceremonial archway put up in the street named after a famous victory at the Battle of Waterloo in 1815. (*Unnamed photographer*)

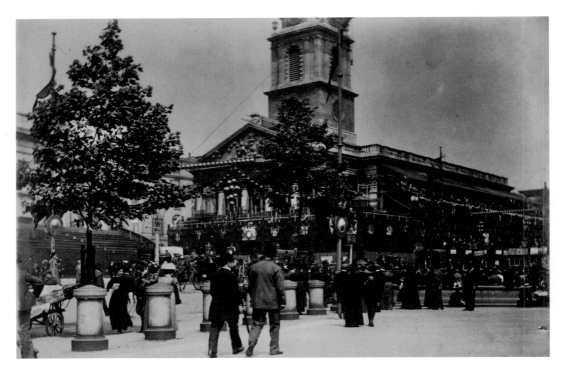

Trafalgar Square: Queen Victoria and Queen Elizabeth II's Diamond Jubilees, 1897 & 2012
Queen Victoria's lengthy jubilee procession included the carriages of visiting royalty, with the Queen herself riding in the State Landau. The familiar route through Admiralty Arch had not then been created but the procession utilised the north side of Trafalgar Square, passing the church of St Martin-in-the-Fields where temporary stands had been provided. St Martin's was a rebuilding from 1721 to 1726, by James Gibbs of the church that, since the twelfth century, had enjoyed a rural setting. In the modern image, the crowds were watching jubilee history unfold on a giant television screen. (*Unnamed photographer*)

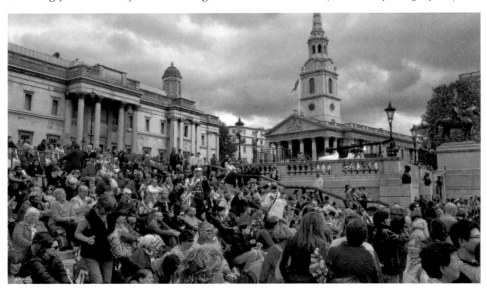

Queen Victoria and Queen Elizabeth II's Diamond Jubilees, Strand, 1897 & 2012
Contrasting moods at jubilee time, with Victorian opulence *v.* modern traffic control barriers.
The early view shows carpenters working on temporary viewing areas, and at A. & S. Gatti's
café-restaurant (centre) a board is visible advertising 'Diamond Jubilee Procession seats to let
in this grand position – 3 to 25 guineas'. Also seen is Lowther Arcade, a children's favourite
which was filled with toy shops. This was rebuilt in the 1970s for Coutts' Bank when the
adjoining 1832 Nash terraces were recreated. (*Unnamed photographer*)

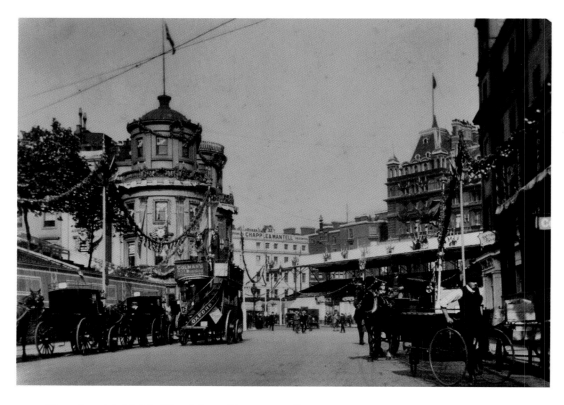

Strand and Adelaide Street from Duncannon Street, 1902
The twentieth century soon brought a new monarch and the start of the Edwardian era.
Edward VII's coronation procession once more filled the streets with joyful crowds and
colourful displays of patriotism. Duncannon Street was part of the old processional route
and where it joined the Strand there were lavish viewing stands across the forecourt of
Charing Cross station. (*Unnamed photographer*)

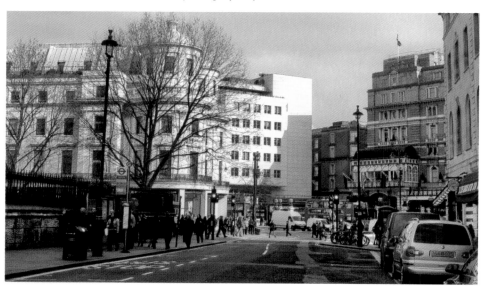

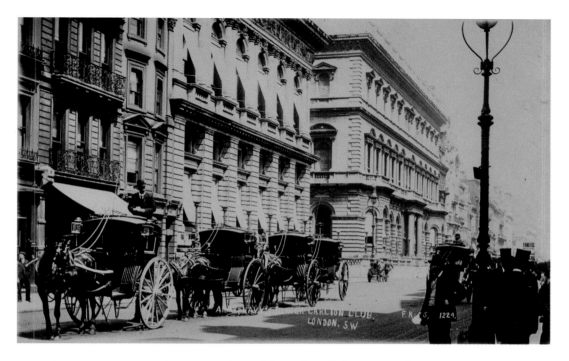

The Army & Navy and Junior Carlton Clubs, Pall Mall, by St James's Square, *c.* 1905
Pall Mall is a particular focus for the great aristocratic gentlemen's clubs that traditionally distinguish the St James's area of London. The foremost one seen here is the Army & Navy Club, which originated in 1837; its imposing clubhouse was built from 1848 to 1851. Beyond the entrance to St James's Square, the even more imposing Junior Carlton Club presents a gloriously extravagant Italianate spectacle, but sadly both buildings have given way to the dreariness which characterised 1960s London. (*Postcard by F. Kehrhahn*)

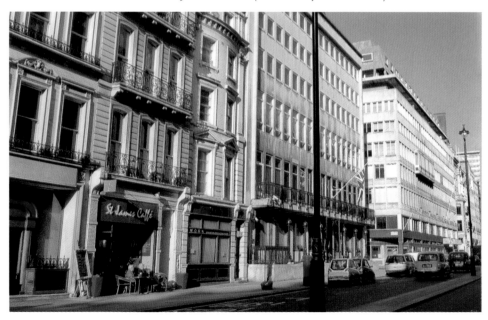

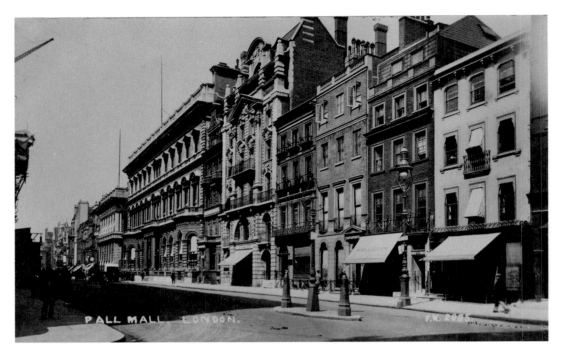

Pall Mall, *c.* 1908
Named from a one-time royal sporting fad 'Pell Mell', the street has long presented a grand and dignified aura, the palace-like gentlemen's clubs alternating with more modest domestic architecture. This mixture is seen here with typically nineteenth-century shops, including that of Messrs Hoby & Gullick bootmaker's adjacent to the showrooms for the Daimler Motor Co., with the mighty Junior Carlton Club beyond. (*Postcard by F. Kehrhahn*)

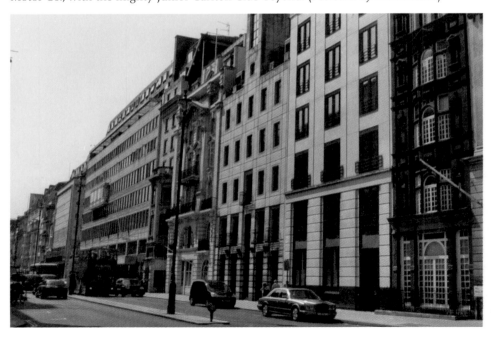

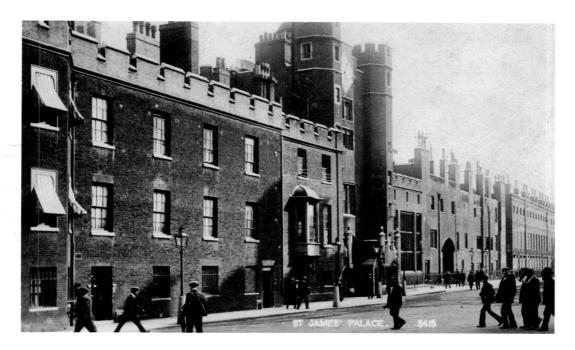

St James's Palace, *c.* 1905

For more than 300 years, this vast and rambling palace was a principal residence of English kings and queens. It was built in 1531 for Henry VIII on the site of St James's Hospital, an establishment founded in the eleventh century, which was latterly a hospital for female lepers. The palace is built of mellow brickwork; its great Tudor gatehouse still looks northwards along St James's Street. (*Postcard by A. & G. Taylor's Reality Series*)

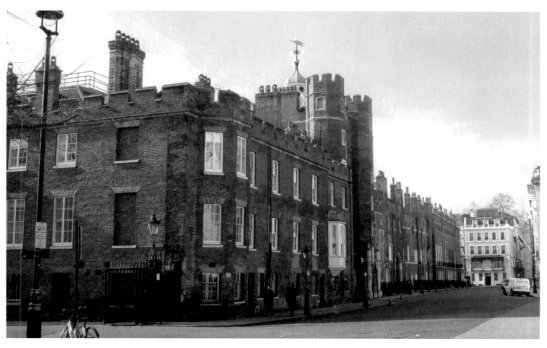

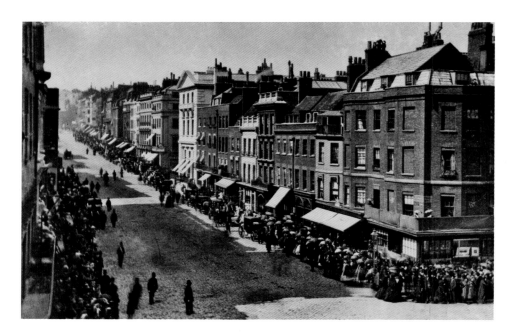

St James's Street from St James's Palace, *c.* 1889
In this street of gentlemen's clubs and fashionable shops, the historic row of properties includes: Berry Bros & Rudd, wine merchant's (1699); Lock's, the hatter's (1676); and J. Lobb, bootmaker's (1850). The former St James's Bazaar, with its grand pediment, is further along. The modern view shows how the corner with Pall Mall, right, was transformed in 1883 by Norman Shaw's handsome building for the Alliance Assurance Co. (*Large mounted photograph by an unnamed photographer*)

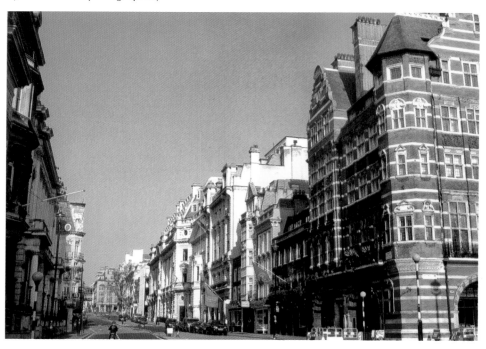

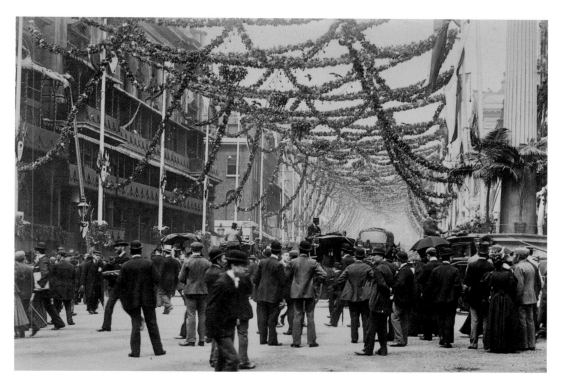

St James's Street: Diamond Jubilee Day, 1897 & 2012
St James's Street was part of Queen Victoria's processional route and was marked here with such fervour, the street all but disappeared amid the opulence of its decorations. This contrasts with Queen Elizabeth II's jubilee, when the focus of attention was elsewhere. (*From a Victorian photograph album, unnamed photographer*)

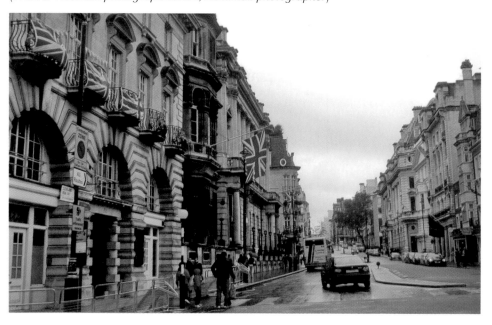

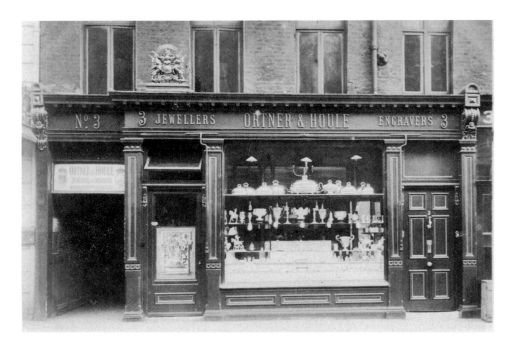

Number 3, St James's Street, c. 1906
This address is famously the home of wine merchants Berry Bros & Rudd, a business that originated around 1699 as a grocer's, specialising in produce from America. The Edwardian view catches the shop when part of it was occupied by Messrs Ortner & Houle, jeweller's and engraver's. The arched windows were revived during a restoration in 1931. To the left is the entrance to the gaslit Pickering Place, dating from the seventeenth century. A plaque here commemorates the presence of the Legation from the Republic of Texas to the Court of St James's from 1842 to 1845. (*Postcard by The Metaline Co.*)

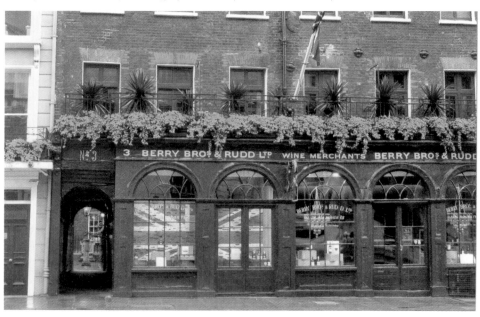

Crown Court (Crown Passage), Pall Mall,
c. 1904
A tiny pocket of modest properties, gaslit and rich, in the atmosphere of old St James's. As with St James's Street, historic businesses survive here alongside the Red Lion pub, whose antiquity recalls the days when stable hands, grooms, carriage drivers and others sought refreshment within. When photographed, Crown Court's traders included a butcher, grocer, bootmaker, and rag and bottle dealer. (*Postcard by F. Kehrhahn*)

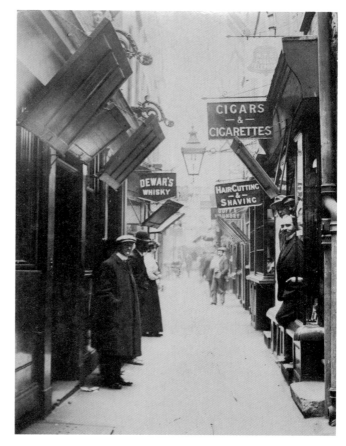

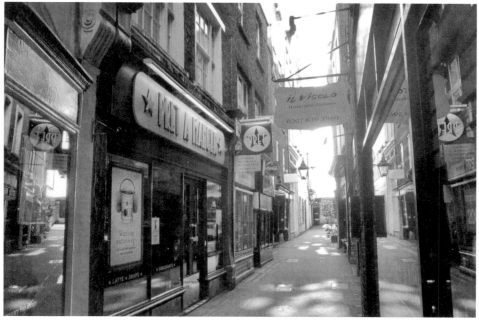

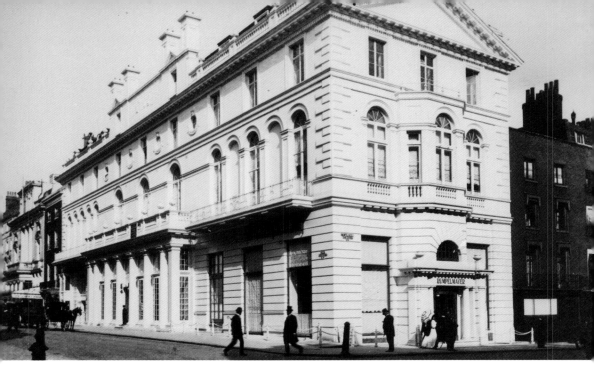

Rumpelmeyer, St James's Street by King Street, *c.* 1909
The building was erected from 1830 to 1832 as St James's Bazaar, but following closure in 1847 the premises underwent many changes of use. In 1907, the Parisian caterers Rumpelmeyer & Co. began a new venture as a fashionable *confiserie* but it was not a success. The handsome building is, however, still standing, albeit with alterations at attic level. (*Postcard by F. Kehrhahn*)

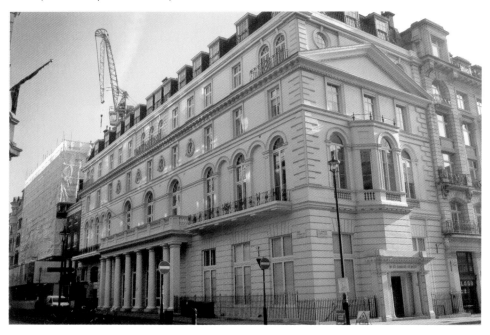

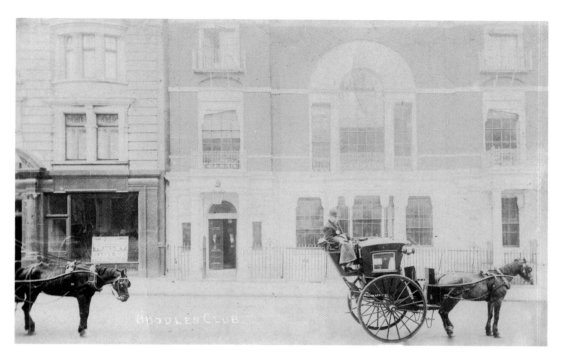

Boodle's, St James's Street, *c.* 1905
The elegant house was built from 1775–76 for the *Savoir Vivre*, a gaming club, but from 1783 it was taken for a new social and non-political club that had been founded by Edward Boodle in Pall Mall in 1762. The club's fine Venetian window still looks out over St James's Street, and although the cab rank is still in use, the old hansoms have long departed. (*Postcard by unnamed photographer*)

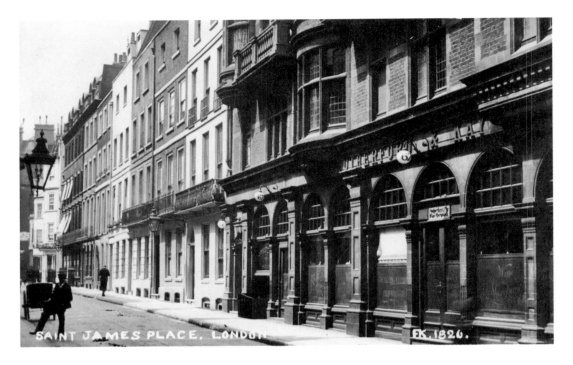

St James's Place, c. 1908

This is part of a secluded enclave of atmospheric, gaslit streets between St James's Street and Green Park. Much of this historic terrace from the late 1600s remains in place, but railed off basement areas have been created. The later building on the right contained Messrs Rutherford & Kay, 'wine merchants to the King and the House of Commons' – this has been replaced by an eye-catching commercial building faced in bronze anodised aluminium. (*Postcard by F. Kehrhahn*)

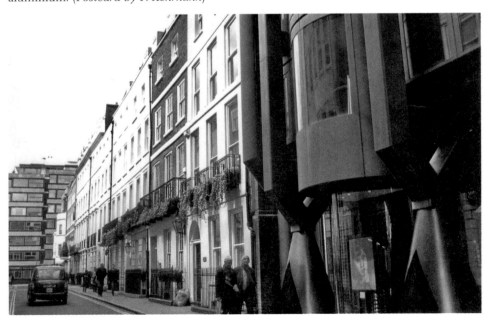

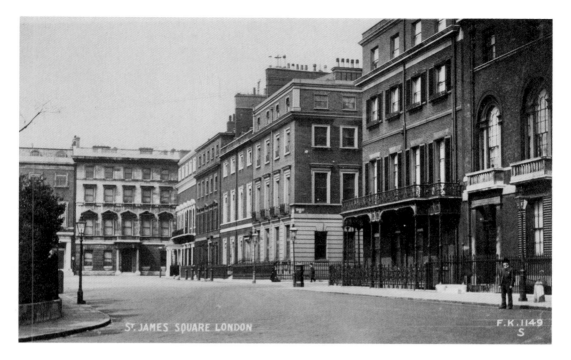

St James's Square: East Side by Charles Street, *c.* 1905

The development of St James's as a fashionable new quarter for London began at St James's Square in the mid-1600s, but no houses from the original project remain. Their replacement included the great aristocratic town houses for which the square is renowned, with gentlemen's clubs maintaining a strong presence. The Edwardian view shows that legacy largely intact, but the twentieth century has been less kind and several fine houses have been lost. Subtle changes to surviving houses are apparent here, but much of the exclusive atmosphere of old remains. (*Postcard by F. Kehrhahn*)

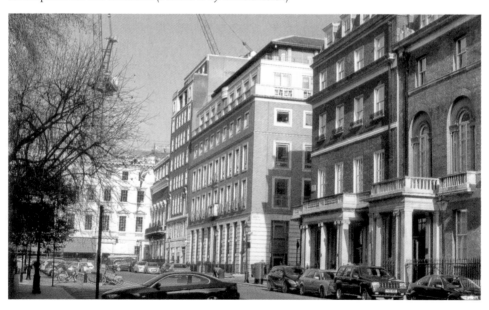

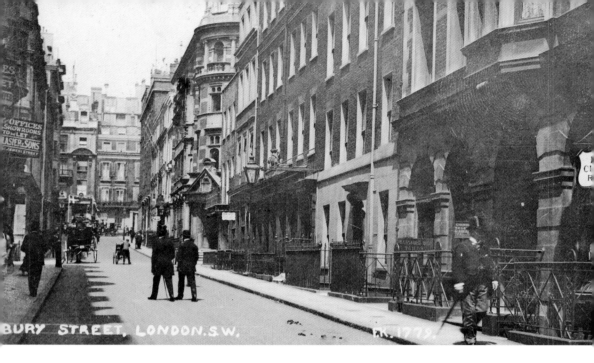

Bury Street, *c.* 1905

This is part of the Earl of St Albans' late seventeenth-century development of St James's. The Edwardian view pictures Bury Street as a place of residential chambers and apartments with a few shops. There was also a single art dealer, an early indication of the type of establishment that would come to characterise the street in later years. (*Postcard by F. Kehrhahn*)

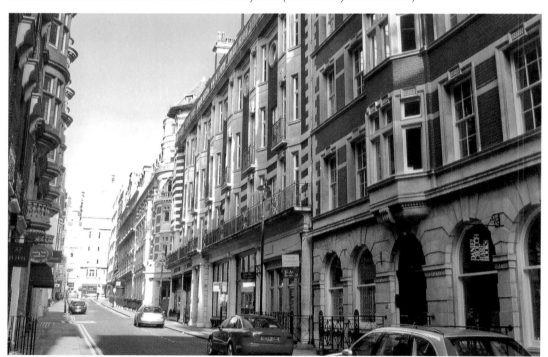

Jermyn Street from St James's Street, *c.* 1908
Noted now for its fashionable gentlemen's emporia and other specialist shops, including the fragrant Floris, perfumers (1730), and cheesemongers Paxton & Whitfield (founded 1740), the street was laid out around 1680 on Crown land, that had been granted to Henry Jermyn, Earl of St Albans. Jubilee flags add colour to the street in 2012. (*Postcard by F. Kehrhahn*)

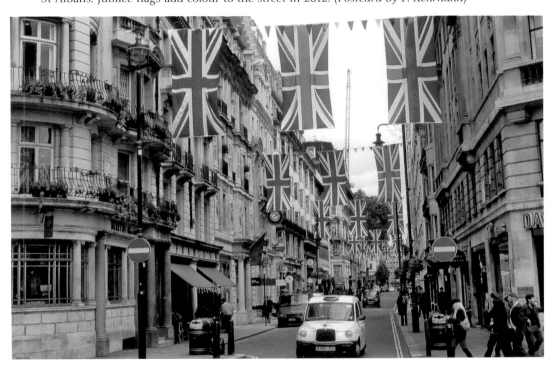

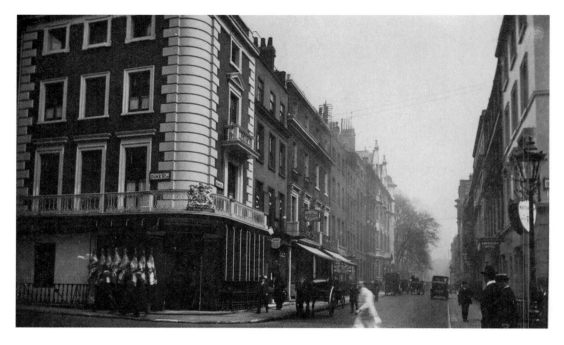

Jermyn Street from Duke Street, *c.* 1910

The butcher's shop of Messrs Slater & Cooke proudly displays its Royal Warrant on the corner premises, while further along, a single shop at No. 44 is part of the Fortnum & Mason business. By contrast, the modern photograph shows how Fortnum & Mason had taken the whole corner in a great rebuilding of 1926 to 1929, running back from its principal frontage in Piccadilly. The Cavendish Hotel (right) occupied what had been a hotel site since the 1700s – it was rebuilt between 1964 and 1966 in a far from traditional design for Jermyn Street. (*Postcard by F. Kehrhahn*)

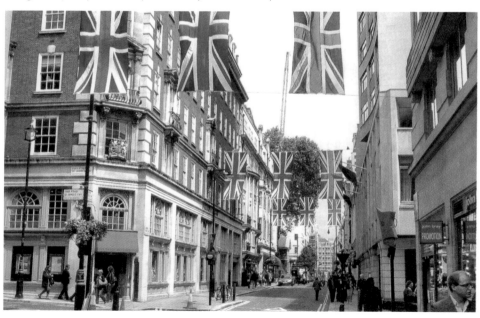

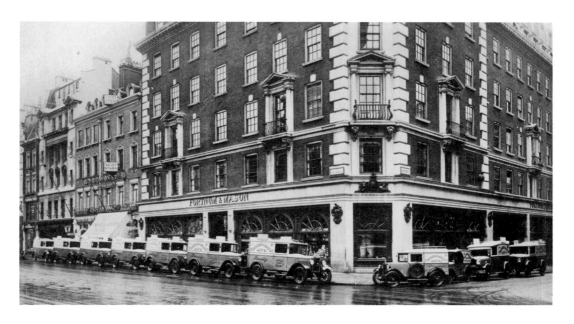

Fortnum & Mason, No. 181 Piccadilly, *c.* 1930
This renowned department store originated in the 1700s, when its founders' connections to the royal household ensured an early dedication to high-quality produce. Prospering through the decades, the business became noted for the luxurious picnic hampers it provided for grand society events, including Ascot, Henley and Glyndebourne. The modern image shows part of the tea party, which ran along Piccadilly and celebrated Queen Elizabeth II's Diamond Jubilee. (*Postcard by Castle Car Co., Camden Town*)

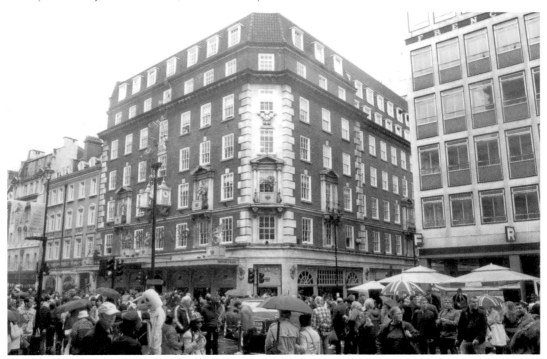

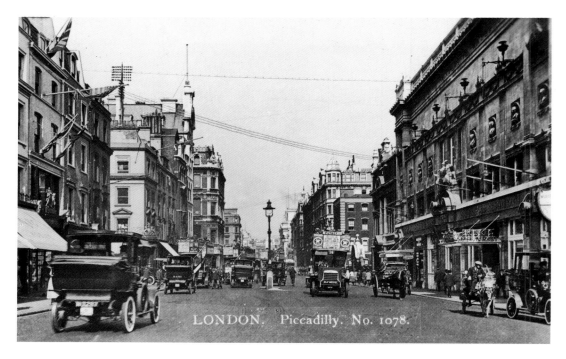

LONDON. Piccadilly. No. 1078.

Piccadilly, Looking East, *c.* 1920
This is the boundary between Mayfair (left) and St James's (right). The St James's side is distinguished by the stone-fronted building for the Royal Institute of Painters in Watercolours (1881–83), who remained in occupation until 1970. The lower floors are seen when they were occupied by the noted Princes Restaurant. Further along is St James's church whose rectory was lost in wartime bombing and subsequently rebuilt in a similar style. (*Postcard by Messrs Degen & Lewis*)

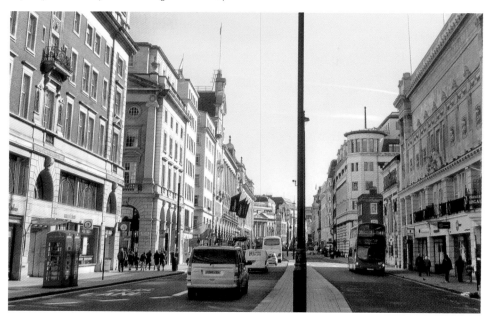

The Site of the Ritz Hotel, *c.* 1880, & the Ritz Hotel, *c.* 1920
The Ritz is one of the world's great hotels, yet in Victorian times its site was home to far more modest enterprises, including a coal merchant. The short-lived Walsingham House Hotel provided some late-Victorian grandeur, but it was Swiss hotelier César Ritz's grand venture that brought glamour and sophistication to this fine site bordering Green Park. The Ritz opened on 24 May 1906. (*Cabinet photograph by Bedford Lemere & Co., and postcard by Messrs Degen & Lewis*)

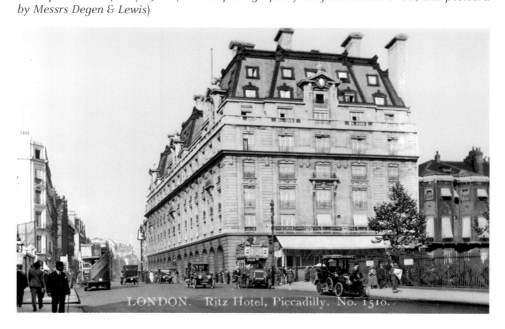

LONDON. Ritz Hotel, Piccadilly. No. 1510.

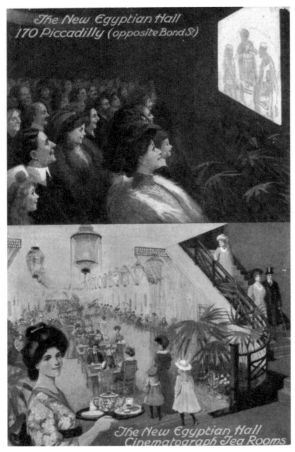

The New Egyptian Hall
170 Piccadilly (opposite Bond St)

The New Egyptian Hall
Cinematograph Tea Rooms

The New Egyptian Hall, No. 170 Piccadilly, c. 1908 Some of London's first exhibitions of projected moving pictures, or 'animated photographs', took place in 1896 at the original Egyptian Hall. These were included in programmes of live entertainment at an exhibition and entertainment venue that opened in 1812. The New Egyptian Hall, rebuilt in 1905, had a 123-seat cinema complete with Japanese-themed tea rooms. The cinema was popular and was later enlarged, but it closed around 1912. The first Egyptian Hall was notable with a dramatic frontage in the Egyptian style, the first time this had been tried in England. The premises as rebuilt in 1905 (now Egyptian House) have a more traditional look. (*Publicity postcard by the New Egyptian Hall*)

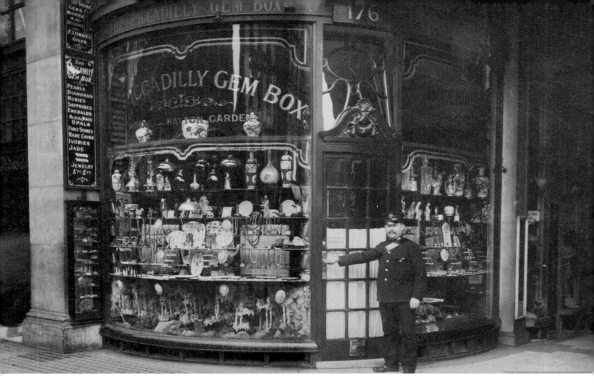

The Piccadilly Gem Box, Piccadilly Arcade, *c.* 1925
Built between 1909 and 1910, Piccadilly Arcade, with its twenty-six bow-fronted shops, continues to provide a luxurious array of emporia in the West End. The Piccadilly Gem Box filled its windows with an alluring display of jewellery and objects, along with a representation of an undersea coral garden. (*Postcard by unnamed photographer*)

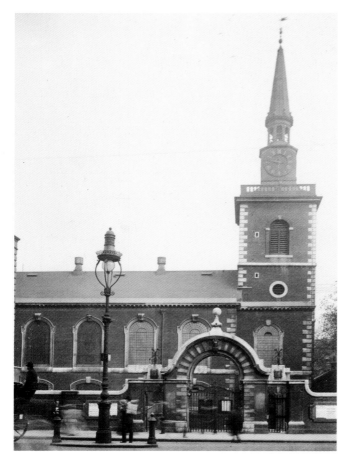

St James's Church, Piccadilly, *c.* **1906**
The church was built from 1676 to 1684 by Sir Christopher Wren to serve residents of what was then a newly-built quarter of London. The church was severely war damaged, but was restored from 1947 to 1954; the spire is now a fibreglass recreation of the earlier lead-covered one. The imposing arched entrance to the churchyard was not replaced. (*Postcard by F. Kehrhahn*)

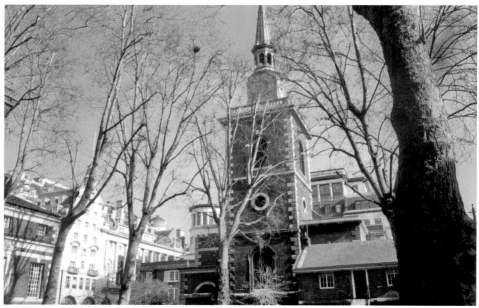